IMAGES
of America

THE JEWISH
COMMUNITY OF
STATEN ISLAND

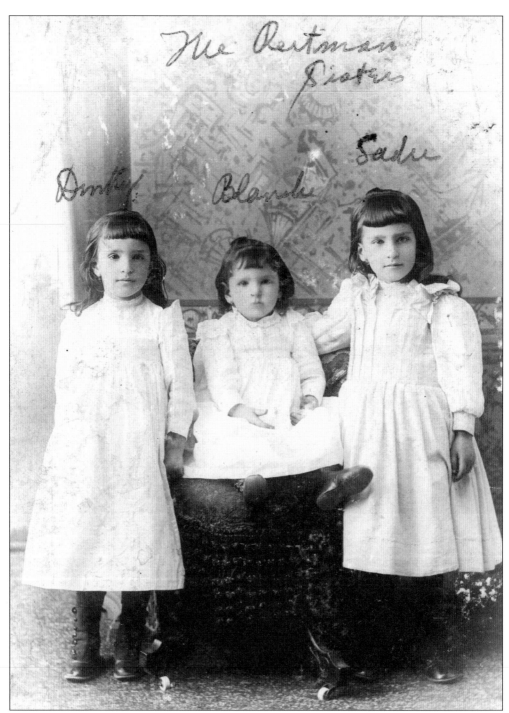

THE REITMAN SISTERS. Shown here, from left to right, are Dorothy (Carter), Blanche (Blum) at age two and a half, and Sadie (Dansky) in 1883. Their mother was born in Baltimore and knew no Yiddish or European language. Their father may also have been born in the United States since he did not have foreign inflection in his speech. The Reitman sisters were born on Staten Island. (Courtesy of Ruth Blum Baker.)

IMAGES
of America

THE JEWISH
COMMUNITY OF
STATEN ISLAND

Jenny Tango
Foreword by Rabbi Gerald Sussman

ARCADIA

First published 2004

Published by Arcadia Publishing
Charleston SC, Chicago IL, Portsmouth NH, San Francisco CA

Printed in Great Britain

Library of Congress Catalog Card Number: 2003107571

For all general information, contact Arcadia Publishing:
Telephone 843-853-2070
Fax 843-853-0044
E-mail sales@arcadiapublishing.com
For customer service and orders:
Toll-free 1-888-313-2665

Visit us on the Internet at www.arcadiapublishing.com

DEDICATION. To Enid Dame (1943–2003), poet, teacher, wife, sister, dear friend, whose feminist poetry reveals new layers of meaning in familiar Jewish biblical stories. Her work will live forever.

CONTENTS

FOREWORD

What does Jewish community mean?

The definition of the term "Jewish community" has been the subject of much debate. At the heart of the discussion is the issue of what makes the Jews unique. What and who is a Jew? This is a difficult question because Jewishness does not fit easily into conventional categories and definitions. We are an ethnic group that one can become part of through religious conversion. Judaism is a religion; however, one can be a total non-believer and still be counted as a Jew. We are among the oldest peoples, yet everywhere new Jewish communities are being built and our ancient heritage is constantly finding fresh and evolving expressions.

One of the things that defines the Jewish community is that time is marked in a uniquely Jewish way. The passage of a year is signified by the festival cycle that recalls the central story of Judaism—the Exodus revelation at Sinai celebrated on Pesach—Shavuot, Sukkot, and calls for introspection and reconciliation on the High Holy Days. The life cycle of birth, coming of age, marriage, and death is also delineated by Jewish rituals. Time is divided into Sabbath and weekdays and flows toward the ultimate redemption.

The Jewish concept of self is to see all Jews as members of one great extended family descended from the ancient patriarchs and matriarchs continuing on to our own day. Because we are one family, we have a special bond with our family members and feel a special closeness and responsibility toward our fellow Jews. We share each other's joys and sorrows and try to come to each other's aid in need. We are taught *kol yisrael arevim zeh l'zeh*, that is, all Jews are responsible for one another, whether in Israel, the former Soviet Union, or right on our own street.

In each and every one of us, the past lives on. We have deep within us the glories of the kings and prophets of ancient Israel. We are deeply scarred by the memories of past horrors and defeats: the destruction of Jerusalem, the massacres of the Middle Ages, the Inquisition, pogroms, and, most tragic of all, the Holocaust. It is important to realize that 60 years later we are still a community in mourning. We are haunted by the question "Can it happen here?" This is why we are so proud of the state of Israel and see its existence as vital to our own future.

Finally, it is true that the universal can best be seen in the particular. In the images contained in this book, we see how people met difficulties, how people enjoyed themselves, how families bonded together, and how groups coped with the issues and needs of their time. Thus, no matter what one's heritage or background, everyone's story is depicted here.

—Rabbi Gerald Sussman, Temple Emanu-El

ACKNOWLEDGMENTS

As a newcomer to Staten Island, having moved here in 1990, I had my first introduction to the Staten Island Jewish community as a result of a chance meeting with Rebbitzin Boni Sussman in 1996. It was, in fact, my first experience of *any* Jewish community since I grew up as a secular Jew. My first marriage had taken place in a synagogue because my observant grandparents were still living. My second marriage, however, took place at Brooklyn's municipal building.

Like many secular Jews, I did not work on Rosh Hashana and Yom Kippur and did not spend any money on Yom Kippur. I celebrated Passover first with my family and then, when family members moved or passed away, with close friends, Jews and non-Jews. I was proud of my Jewish heritage and read many books on Judaism and Jewish history. I felt I was very connected, but as I learned from the Jewish community of Staten Island, I was "unaffiliated." I became a member of Temple Israel, a Reform congregation, and joined its Torah study group, which was conducted in English.

Interested in learning more about Staten Island's Jewish community, I discovered that the books about Staten Island provided very little information. Frustrated, I decided to try to fill the gap. I joined Temple Emanu-El, an old Staten Island Conservative synagogue, and began my journey through 19th- and 20th-century Staten Island to find its Jewish community. I am indebted to all the people who have so generously contributed memories, stories, and images to help me create *The Jewish Community of Staten Island* as a tribute to this unique place.

Rabbi Gerald Sussman of Temple Emanu-El was my general guide. I received support and assistance from Rabbi Steven Stern, executive director of the Staten Island Jewish Leadership Consortium; Rabbi David Katz and president Wayne Schwartz of Temple Israel; and Ruth Lasser and Kathy Morano of the Jewish Community Center. Richard Dickenson, historian of Staten Island; Carlotta DeFillo, librarian of the Staten Island Historical Society; Patricia Salmon, history curator; and Dorothy DeLitto, librarian of the Staten Island Institute of Arts and Sciences, have been inexhaustible resources. Special thanks go to publisher Richard Diamond, editor Brian Laline, photography editor Steve Zaffarano, librarians Mary Cassano and Maureen Donnelly, Melinda Gottlieb, and the wonderful writers and photographers of the *Staten Island Advance* whose articles, images, and generosity contributed so much to this work. I was fortunate in having the invaluable collaboration of Channell Graham, who undertook the enormous task of scanning and organizing the images I collected.

Boni Sussman, now a rabbi, continued to come to my aid in every way imaginable. Cantor Suzanne Bernstein appeared miraculously when she was most needed. Caryn Davis Roth and her four-month-old daughter, Lili Grace, chauffeured me at a crucial moment. Saadyah Averick and Yehuda Kaufman of Yeshiva Tiferes Torah were considerate hosts. The Temple Emanu-El secretary, Barbara Niler, made it her responsibility to see that I never lost touch with its busy rabbi. My husband, Robert Bunkin, despite his own crushing schedule as a painter and assistant professor of art history, often pointed me in the right direction. My editor, Jennifer Durgin, saw me through the process with enthusiasm, faith, editing shears, and a sense of humor. Lastly, thanks to Tamara Coombs, independent writer and researcher, and Rhoda Lewin, author of Arcadia Publishing's *The Jewish Community of North Minneapolis,* for without their push, this book would have remained just an idea.

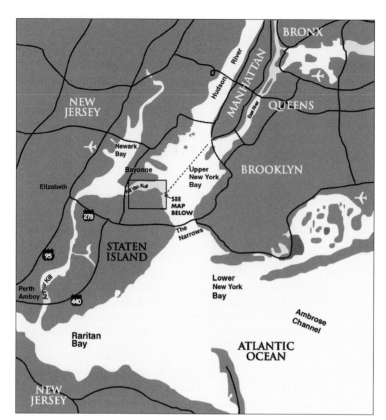

STATEN ISLAND. This 2004 map shows the location of Staten Island in reference to the other four boroughs, New Jersey, and the New York Bay. Staten Island was connected to New Jersey by three major bridges (Bayonne, 1931; Goethals to Elizabeth, 1928; and Outerbridge Crossing to Perth Amboy, 1928) and to Brooklyn by the Verrazano-Narrows Bridge in 1964. Its only connection to Manhattan is the St. George Ferry. See inset enlarged below. (Map by Tina Bliss.)

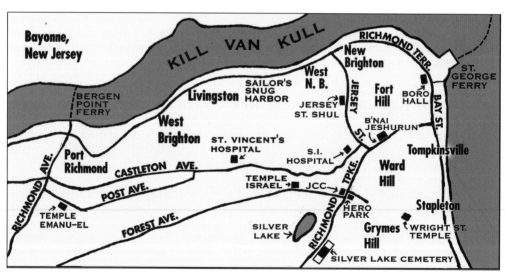

THE NORTH SHORE. Revealed here are the major streets and institutions relating to the history of the Jewish community. Commuting by ferry was a fact of life for many Staten Islanders who traveled to Manhattan for business, personal, and religious reasons. Wealthy Staten Islanders built their homes on the hills overlooking the bay. Forest Avenue was originally the forest line.

INTRODUCTION

A lot of New Yorkers think Staten Island is outer Siberia.
—Gretchen Anthony,
Staten Island tour guide quoted by David Andreatta,
Staten Island Advance, 2003.

To many New Yorkers, Staten Island is a mystery, and to many Staten Islanders, the Jewish community of Staten Island is a mystery. Getting off the ferry to Staten Island at the St. George terminal may help solve the first mystery. Since there are no exclusively Jewish residential or market areas and Jewish people look and act like everyone else, this book can help illuminate the second.

Staten Island is 13.9 miles long and 7.3 miles across its widest part, with 35 miles of waterfront, and is unconnected to any other landmass except by ferry and bridge. Separated from New Jersey on three sides by the Kill Van Kull and Arthur Kill, it looks, geographically, like part of New Jersey, but historically, it has always been part of New York. Once an important center of Colonial history, the summer playground of Manhattan's high society, and the location of early movie westerns, Staten Island became "the forgotten borough" in the 20th century.

Staten Island and Brooklyn present two sides of "the Narrows," the gateway to New York Harbor. In 1880, Brooklyn had a population of almost 600,000 and was one of 20 U.S. cities with a population over 100,000. At that same time, only 2,500 Jews lived in the entire United States. The majority of all immigrants ended up in Manhattan, but because New Jersey was closer to Ellis Island, many immigrants chose to head there and points west. The opening of the Brooklyn Bridge in 1883 and the Williamsburg Bridge in 1896 provided outlets for the overflowing immigrant population of lower Manhattan. As for Staten Island, it seemed to offer the least accessible and inviting option for new immigrants landing on Ellis Island. If they went to Staten Island, they mostly went to join relatives.

Itinerant Jewish peddlers came to Staten Island early in the 19th century but did not stay, preferring to live near those of their own faith in Manhattan, where there were 400 Jews by 1812. Jewish immigrants who did take up residence on Staten Island in the last half of the 19th century were a very small minority on the sparsely populated island. They tended to settle in the more populated areas of Staten Island, clustered around the Arietta Street, St. George, Bergen Point, and Perth Amboy ferries. In 1886, the St. George Ferry became the terminus for the ferries, trolleys, and Staten Island Railroad, making it the island's most important link to Manhattan and contributing to the business and residential growth of the North Shore. It is the only ferry in service today and still the only direct access to Manhattan.

The bill that combined five boroughs into New York City became law in 1898. Staten Island, with its iron mines and breweries, farms and shipbuilding yards, hills and marshes, was now a borough. By 1930, a third of Brooklyn's large population was Jewish, and 47 percent of all the Jews in New York City lived there. The opening of the Verrazano-Narrows Bridge, connecting Staten Island and Brooklyn in 1964, resulted in an increase of Staten Island's population from 220,000 in 1960 to 352,000 in 1980. The Jewish population increased 200 percent to 31,000,

or 9 percent of the total population, with a large concentration of Orthodox Jews in Willowbrook. More recently, Jewish households have appeared in Arden Heights, Eltingville, and around Great Kills Park in the southern third of the island.

An article in Hagedorn's *The Staaten Islander Semi-Weekly, A Family Paper, Devoted to the Diffusion of Useful Knowledge, Polite Literature, and the Local News and Interests of Staaten Island,* noted in 1856 that "Staaten Island owes very little indeed to its individual or associated enterprise, but her population increases at the rate it does, from the necessities of its position." At present, due to the shortage of affordable housing in the other boroughs, Staten Island is experiencing for the first time in its history the largest growth of population of all the boroughs. The Jewish community grew by 27 percent from 1991 to 2001 to a total of 42,000 people, for the first time topping Brooklyn's increase of 23 percent in the same period. Despite this rise in population, Staten Island's Jews are still a small minority.

A large population, however, is not necessary in order to create a Jewish community. In 1734, there were only 20 Jews recorded in Manhattan, but they purchased a burial ground in 1728 and owned a synagogue in 1730. It took only 12 Jewish men to found the first synagogue on Staten Island in 1888.

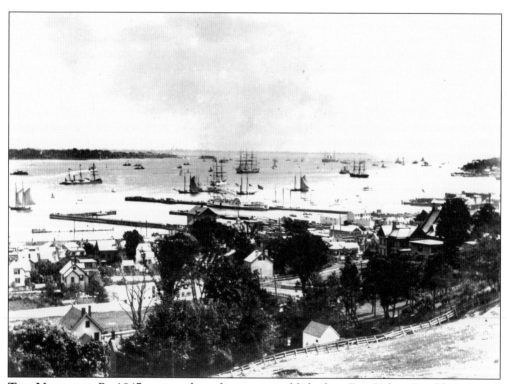

THE NARROWS. By 1847, a steamboat ferry was established to Bay Ridge, Brooklyn. Staten Island's buildings, mostly two stories high and at the most three, clung to areas along the eastern shore. This view was photographed from Stapleton Heights by Isaac Almstaedt c. 1885. (Courtesy of the Staten Island Historical Society.)

One

SETTLING ON

STATEN ISLAND

*That the Jewish movement is essentially a family movement is shown
by the great proportion of females and children in it.*

—Irving Howe, *The World of Our Fathers*, 1976.

In 1641, the Dutch granted land on Staten Island to Jacob Saloman, who owned property in Brooklyn and Long Island. He does not seem to have actively settled there. A large, possibly Sephardic Jewish family engaged in agriculture from the 1830s to the 1840s in Egbertsville. The will of Sarah Levy was filed in 1835. Formerly of Jamaica, British West Indies, she named her seven children and left her farmland and tenements in Richmond County, equally, to two of her sons. By the 1845 census, none of the family was listed.

The first trickle of Jews were from Germany. Moses Greenwald came to the United States on a small sailing vessel to escape the Revolution of 1848. The first place the ship docked was at Staten Island. Greenwald got off, vowing not to get into another boat ever again in his life, having been seasick the entire voyage. As he did not meet a single other Jew, he called himself "the first Jew on Staten Island" and his son Abraham "the first Jew born on Staten Island." Abraham and Rachel Almstaedt came to Tompkinsville in 1850. The Almstaedts lived at 11 Richmond Turnpike and belonged to Congregation B'nai Jeshurun. Askiel and Doris Isaacs came to Staten Island in 1868. They had five children: Max, Arthur, Jessie, Carl, and Marie. Marie married Reuben Mord, whose father, Alter, had opened up a dry goods store on Staten Island in 1881. Alter regularly attended a synagogue in Manhattan. Determined to have a Jewish place of worship on Staten Island, he joined Askiel Isaacs as founding members of B'nai Jeshurun. Carl Isaacs attended New York University, graduated from the New York Law School, and practiced real estate law. Carl was a founding member of Temple Israel.

Eastern European Jews soon made up the majority of Jewish settlers. Between 1903 and 1906, the 300 pogroms in Russia from Kishineff to Bialystok were so devastating that whole families and towns fled Eastern Europe. Increased legal and economic restrictions impoverished those who remained. Between 1881 and 1914, a small number of the two million Eastern European Jews who arrived in the United States found their way to Staten Island. Jewish immigration to Staten Island did not stop with these two major migrations. In the 1930s and 1940s, European Jews fled the rise of German Nazism, and after World War II, Holocaust survivors arrived as well. Soviet Jews, able to leave under the *glasnost* policy, began arriving as early as 1989. As of 2003, there are 11,000 Russian Jews, many of them living in waterfront communities such as Prince's Bay, Midland Beach, and South Beach.

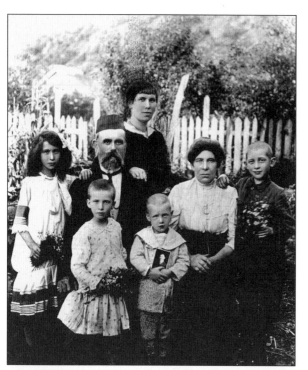

UNDER THE CZAR. This photograph of the Baker family was taken in Russia to send to Nathan Baker in the United States. Shown here, from left to right, are the following: (first row) Henrietta and Abraham, holding a picture of his father; (second row) Dorothy, Grandpa and Grandma Friedman, and Samuel; (third row) Diana Friedman Baker. Not too long after this photograph was taken, a band of Russian soldiers came into the village. Diana and her children hid for fear of rape. When the grandparents opened the door at the knock of the soldiers, they were shot point-blank and killed instantly. Diana and her children joined Nathan in the United States soon afterward. (Courtesy of Ruth Blum Baker, wife of Abraham Baker.)

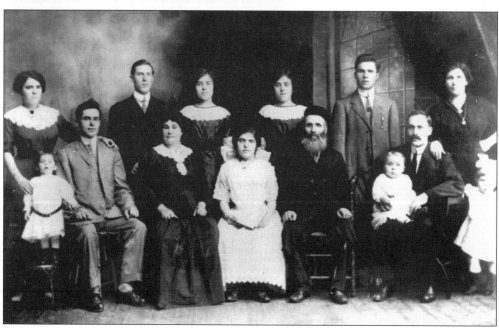

ENTIRE FAMILIES COME TO AMERICA. This 1910 photograph includes the following: Irving Rivkin (later tax commissioner of New York City); "Bubba," Bella, and "Zayde" Mordecai Rivkin; Morris with son Mitchell and daughter Sarah; "Little" Ida; Samuel Rivkin; twins Bessie and Celia; Joseph Rivkin (who married Sara Minkowsky, ran a plumbing business, founded the Staten Island Jewish Community Center, and died at 39, killed by a drunk driver); and "Big Ida." (Courtesy of Edith Rivkin Susskind.)

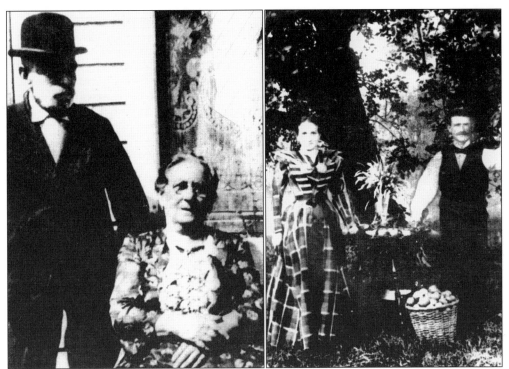

WEISSGLASS FARM. Grandpa Max and Grandma Mindel Weissglass (above left) married in Poland when he was 18 and she was 15. He came to America in 1887 and she in 1893. Before buying a farm on Staten Island with his son Julius, Max worked in a poison-gas factory. Mindel's father was an outstanding Polish rabbi. Julius Weissglass (above right) met his wife, Julie, in New York City through a distant relative. Julie could speak six languages. A hard-working mother of five, she died at 41 in 1913 and lies buried next to Julius (d. 1946) in Baron Hirsch Cemetery. (From *Smiling Over Spilt Milk*, by Charles Weissglass, with permission from Alan Weissglass.)

HERE TO STAY. Louis Cohen and his family became citizens of the United States in 1914. While 66 percent of the total number of immigrants to the United States between 1908 and 1924 remained permanently, 94.8 percent of those who were Jewish remained. (Courtesy of Joel Cohen.)

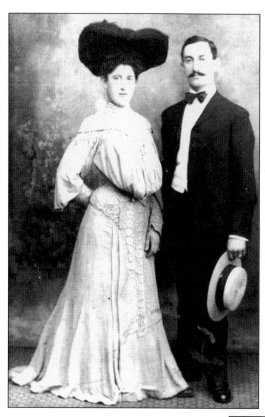

MARRIED TO THE BOSS'S DAUGHTER.
Yetta's father owned Krancer Dry Goods
on Jersey Street. She is pictured with her
new husband, Anson Susskind. Although
dry goods was a common Jewish business,
not all dry goods stores were owned by
Jews. (Courtesy of Edith Rivkin Susskind.)

THE DIAMOND FAMILY. Jacob and
Lotte Diamond came to New York
City in 1887 from Russia. They had
Michael in 1890 and Morris in 1892.
Michael was sickly, so the doctor
advised a move to "the country." In
1894, the family moved to a building
owned by Joseph Rivkin on Jersey
Street and opened a dry goods store.
Joseph (a doctor) and Ben (a dentist)
were born on Staten Island. Joseph
married Gertrude Newhouse. Their son
Richard was the publisher of the *Staten
Island Advance* from 1979 to 2004. His
daughter Caroline Diamond Harrison
is the present publisher. (Courtesy of
Harold Diamond.)

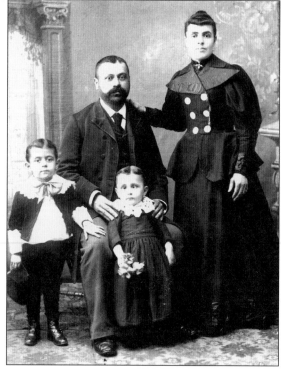

14

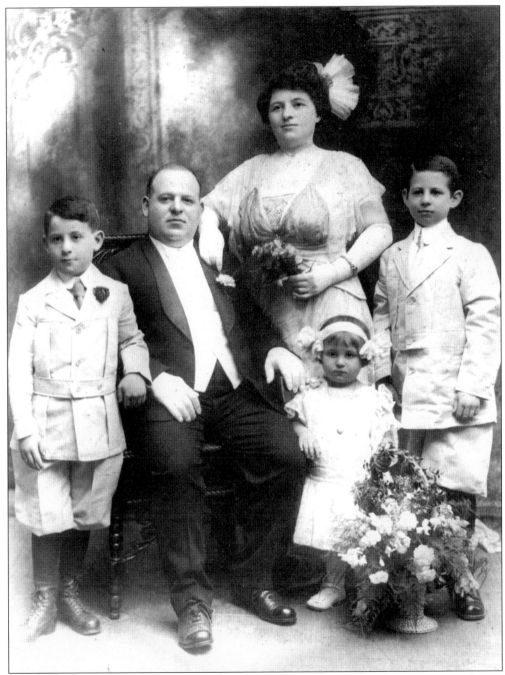

THE KLEIN FAMILY. Morris and Anna Klein pose in 1916. The children, from left to right, are Walter, Arthur, and Mildred. A fourth child, Elinor, was not yet born. The Klein family came to Staten Island from Perth Amboy, New Jersey. (Courtesy of Monroe and Marcia Siegler Klein.)

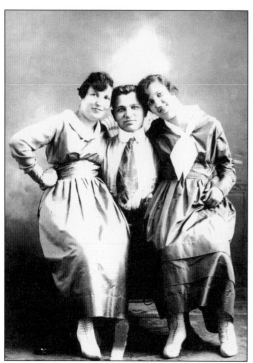

JACOB HORN IN MONTREAL. Jacob's wife, Esther Zeitchik, sits on the left and her sister Cele on the right. Born in Russia, Jacob immigrated to America, where many of his relatives had come earlier. Fluent in French, Jacob moved with his new wife to Montreal. Esther could not speak French and missed her family. They moved with their 15-month-old son, Jason, to Staten Island, where Jacob's cousin Shane Cooper lived, and opened a grocery store. (Courtesy of Rosalie Horn Brayman.)

ABOVE GREGORIO'S. The Welkowitz family lived in an apartment above Gregorio's Florist Shop in the 1930s. On Jersey Street, stores were on street level, and above the stores were apartments. These were often the first homes of new immigrants. Gregorio's Florists moved to West New Brighton in 1935 and to its present location at 570 Forest Avenue in 1940. (Courtesy of Sam Gregorio.)

"VOYAGE OF THE DAMNED." In 1939, Egon Salmon, 16, his sister Edith, 7, and their mother, Erna, were on the ocean liner *St. Louis* to join their father, Paul Salmon, in Cuba. Refused entry to Cuba, the ship, bearing more than 900 Jewish refugees, returned to Europe. Half of the people aboard perished at the hands of the Nazis. The three Salmons left Belgium one month before it was invaded, and the whole family came to Staten Island in 1940. (Courtesy of Egon Salmon.)

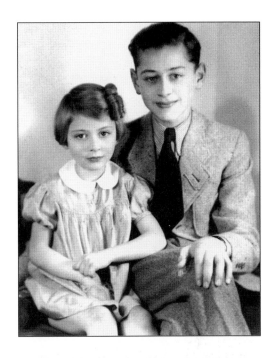

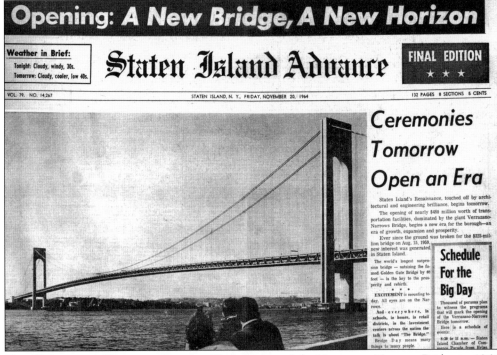

THE VERRAZANO-NARROWS BRIDGE. The opening of the Verrazano-Narrows Bridge in 1964 had a great impact on Staten Island. Many Italian and Jewish families from Fort Hamilton and Bensonhurst moved to Staten Island. Italian Catholics are now the single most populous group on Staten Island. Jewish families moved into single-family housing developments along the new expressway to New Jersey. (Courtesy of the Staten Island Institute of Arts and Sciences.)

A Russian Bat Mitzvah. Joel and Nancy Cohen and their daughter Ann sponsored a bat mitzvah for Olga Fonaryov, in white, at Temple Israel. (Courtesy of Joel Cohen.)

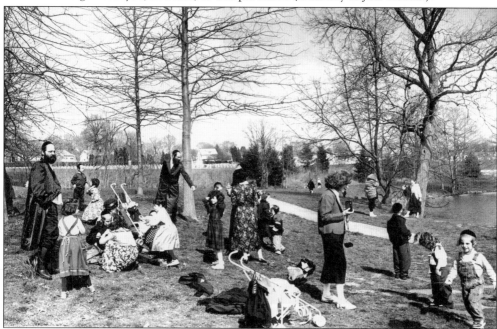

Enjoying Passover at Martling Pond. Many Hasidim come from Brooklyn with their families to spend an afternoon at Clove Lake Park, the Staten Island Children's Museum, and the Staten Island Zoo, or to visit family and friends on Staten Island. (Courtesy of the *Staten Island Advance*.)

Two

BUILDING A SYNAGOGUE

*. . . the synagogue never lost its central role as the focus of Jewish life in the shtetl
and in the city, as a house of prayer and a house of assembly.*

—Geoffrey Wigoder, *The Story of the Synagogue*, 1986.

Between 1860 and 1880, a small group of Jewish families settled in Tompkinsville, Stapleton, Clifton, and Rosebank. Jews were probably gathering for prayer service within a few years after the Civil War. In 1867, a letter signed by A. Almstaedt appeared in the *Richmond Gazette* thanking Tompkins F. & A. M., a Masonic organization, for the use of the lodge's room for Rosh Hashana and Yom Kippur. An attempt to organize a synagogue was made in 1869. Staten Island's first synagogue, Congregation B'nai Jeshurun, opened on Richmond Turnpike in 1894.

At a meeting in 1904, Port Richmond businessmen laid the groundwork for the 1907 Conservative synagogue Temple Emanu-El. Dr. George Mord, medical examiner of Richmond County, was president for five years. An education building was constructed in 1927. In 1900, the Orthodox Agudath Achim Anshe Chesed Congregation was founded. Its synagogue was erected in 1913 at 386 Jersey Street. Temple Tifereth Israel was organized on Wright Street in Stapleton in 1916 and Congregation Ahavath Israel in Tottenville in 1926. B'nai Israel, founded in 1930 in Grant City, relocated to Bay Terrace in 1968. The congregation of the first and only Reform synagogue on Staten Island, Temple Israel, came together in 1947. The congregation bought the Gans estate at 800 Victory Boulevard in 1951 and renovated the main building to provide a chapel, pulpit, and space for a choir and organ. After a fire destroyed that synagogue, the present one was built in Randall Manor and was opened in 1964. These were the seven synagogues, mostly on the North Shore, known as the "Old Jewish Community".

The Staten Island Yeshiva was established by Rabbi Moshe Feinstein in Pleasant Plains in 1967. The Rabbi Jacob Joseph School for boys arrived from the Lower East Side in 1975. It also has a preschool and kindergarten program at a Willowbrook synagogue and a girls' school, Bais Yaacov. Girls can also attend the Jewish Foundation School. Staten Island has 10 synagogues that sponsor supplementary schools. Nevertheless, hundreds of Orthodox children are bussed to Brooklyn schools.

Staten Island synagogues were never as large as those found in Manhattan and Brooklyn. Their congregations were small. The average number of families involved in each synagogue ranged from 50 to 400, with most around 220 at their peak. This holds true for synagogues founded more recently. Two Willowbrook synagogues share the same building but have their own rabbis: Rabbi Emanuel Pollack is the spiritual leader of Agudath Shomrei Hadas and Rabbi Ezra Adomi of Shevet Achim. Beth Shloime is sometimes called "Rabbi Isaccson's Shul" because it was founded by the late Hassidic scholar. This unpretentious shul is also called the "Cheers" of shuls for its members enjoy it so much. Young Israel of Eltingville, an Orthodox congregation ably led by Sid Stadler who brought in a *Kollel* (a Talmudic seminary), recently built a *mikvah* (a ritual bathhouse) and *eruv* (a boundary for maintaining the sanctity of Shabbos observance). There are now a total of 23 congregations in various parts of Staten Island that cover the entire religious spectrum.

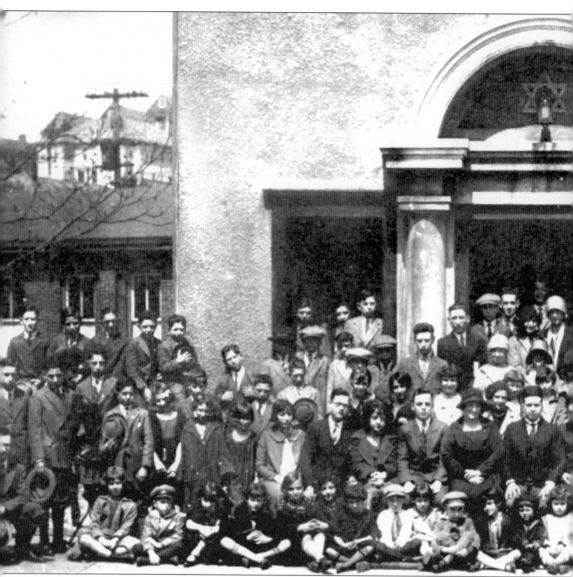

THE FIRST SYNAGOGUE. The entire Sunday school poses in front of B'nai Jeshurun. The school's leader was Sidney Marcus, who oversaw the teaching of Jewish history, ethics, and Jewish holidays and festivals. The first cantor of B'nai Jeshurun was Jacob Levy, and Mr. and

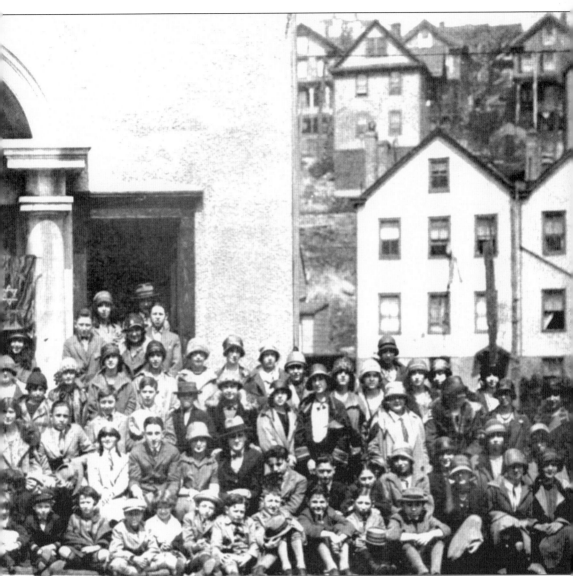

Mrs. Louis Kassner had the first marriage at the synagogue. Cemetery plots were bought at Silver Lake Cemetery in 1893 and 1913. Other plots were purchased later at Baron Hirsch Cemetery. (Courtesy of Joel Cohen.)

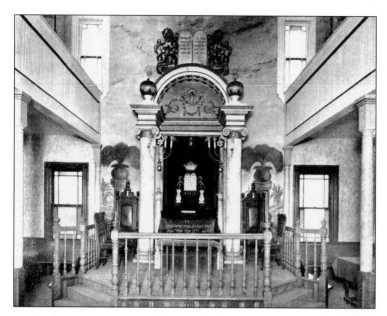

THE BEMA. In 1920, B'nai Jeshurun was renovated and a new *bema* ("altar") constructed. As a result, membership and services greatly increased under the leadership of Rabbi Leon Horowitz. (Courtesy of Joel Cohen.)

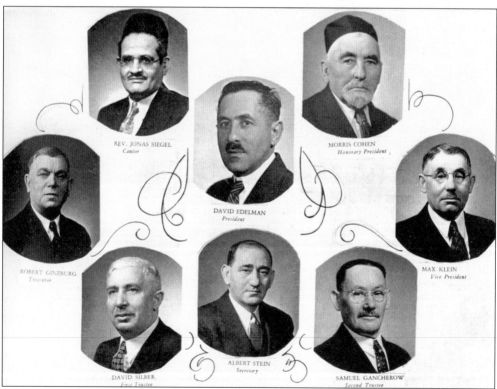

REV. JONAS SIEGEL
Cantor

DAVID EDELMAN
President

MORRIS COHEN
Honorary President

ROBERT GINZBURG
Treasurer

MAX KLEIN
Vice President

DAVID SILBER
First Trustee

ALBERT STEIN
Secretary

SAMUEL GANCHEROW
Second Trustee

THE OFFICERS OF THE CONGREGATION. The officers of 1933 pose for a photograph. The founders of B'nai Jeshurun in 1884 were Morris Cohen, Alter Mord, Isador Kutscher, Abraham Jacobs, Michael Isaacs, Jacob Ronner, Jacob Levy, Joseph Frank, Israel Schimansky, Morris Mord, and Levy Isaacs. David Berezowsky, who opened a kosher butcher shop on Jersey Street at the behest of the members, joined their ranks. (Courtesy of Joel Cohen.)

THE MEMBERS OF B'NAI JESHURUN. The original founders met in the home of Morris Cohen for services on the first day of Succoth in 1884. B'nai Jeshurun opened for services on the first day of Succoth in 1894. (Courtesy of Joel Cohen.)

B'NAI JESHURUN SISTERHOOD. The Ladies Hebrew Charitable Society was organized in 1900 to help the Jewish poor. From 1909 to 1918, they provided layettes and financed *brises* for the children of wayward Jewish girls at the Lakeview Home and did charity work during the war. (Courtesy of Joel Cohen.)

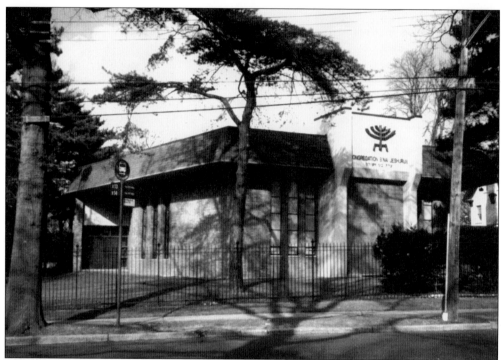

B'NAI JESHURUN MOVES. B'Nai Jeshurun took over the old Steer and Steers Funeral Home at Martling Avenue. In 1973, a tent was erected on the grounds of the site of the proposed building to hold High Holy Days services. Shortly thereafter, ground was broken for the new building, which would contain a sanctuary and social halls. The completed building, designed by Albert Meliker, was dedicated in 1975.

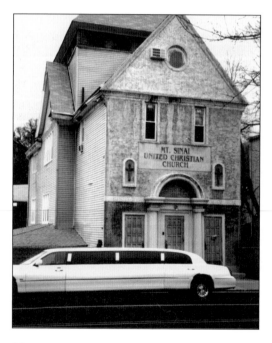

MOUNT SINAI BAPTIST CHURCH. After B'Nai Jeshurun moved in 1970, its old building was occupied for three years by a day-care center. From 1977 to 1987, it was the home of the New Brighton Jewish congregation. Its next owner, Janet Falcon, stored antiques there for her store on Bay Street for five years. Finally, Mount Sinai Baptist Church bought the building in 1994.

THE JERSEY STREET SHUL. The Jersey Street Shul was built by Steinberg & Siegler in 1913. A building behind the shul at 303 York Avenue was purchased soon after to provide for a Talmud Torah, a mikvah, and a residence for a rabbi. It was the home of Congregation Agudath Achim Anshe Chesed until 1970. (Courtesy of the *Staten Island Advance*.)

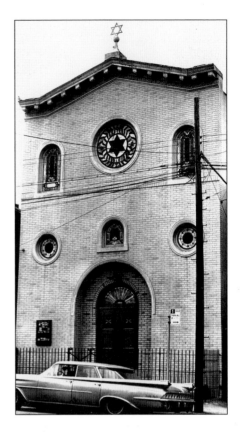

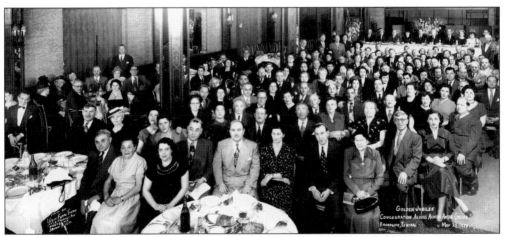

THE GOLDEN JUBILEE. The Torah tells Jews to celebrate their jubilee every 50 years. During this yearlong festival, in ancient times, the land was left to rest, slaves were released from bondage, land was returned to its original owner who was forced to sell it, and debts were forgiven. It is interesting to note that the jubilee here was celebrated off-island at the Broadway Central Hotel in 1950. (Courtesy of Joel Cohen.)

"Triple A" Honors Its Rabbi. In 1964, a testimonial dinner was given in honor of Rabbi Morris Zachariash on his 10th anniversary as rabbi of Agudath Anshe Achim Chesed. Rabbi Zachariash regularly provided comfort and services for the Jewish residents of nursing homes.

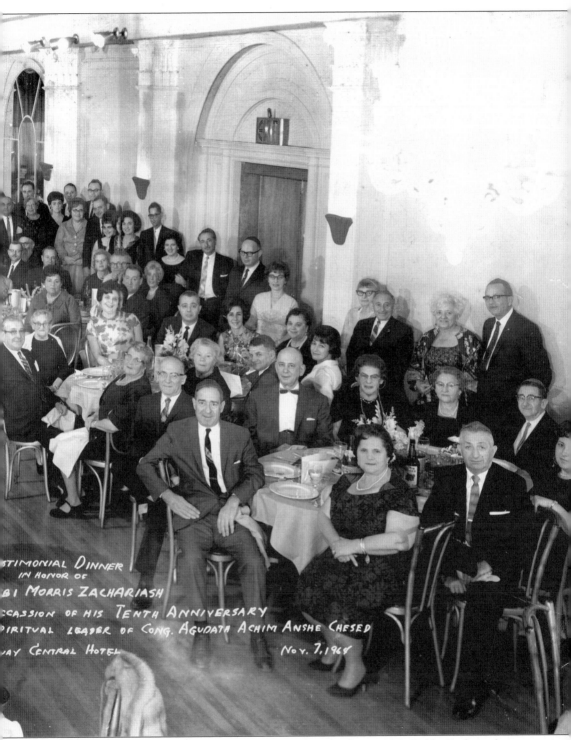

As a Mohel, he performed circumcisions all over the island. In 1975, Rabbi Zachariash was voted lifetime tenure. (Courtesy of Joel Cohen.)

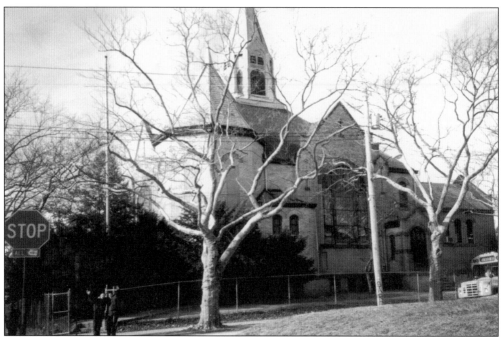

FROM CHURCH TO SYNAGOGUE. The Jersey Street Shul bought and occupied the former Methodist church in West New Brighton in 1970. As the congregation aged on Jersey Street, the shul established an innovative, tuition-free Hebrew school hoping to attract young people. Unfortunately, the experiment failed due to the changing demographics of the neighborhood. Still devoted to Jewish education, Agudath Anshe Achim Chesed now houses the Yeshiva Tiferes Torah.

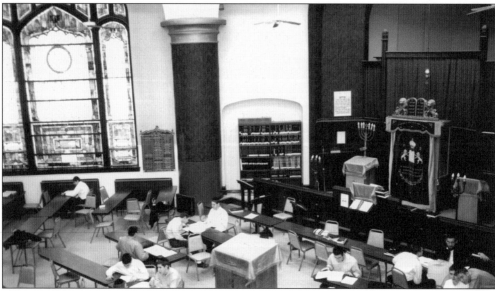

YESHIVA TIFERES TORAH. Yeshiva students study in the sanctuary. Boys from Brooklyn, New Jersey, and Staten Island are enrolled in grades 9 through 12 and attend six times a week. The curricula include Judaic and secular studies and college preparation. Rabbi Mayer Friedman serves as dean.

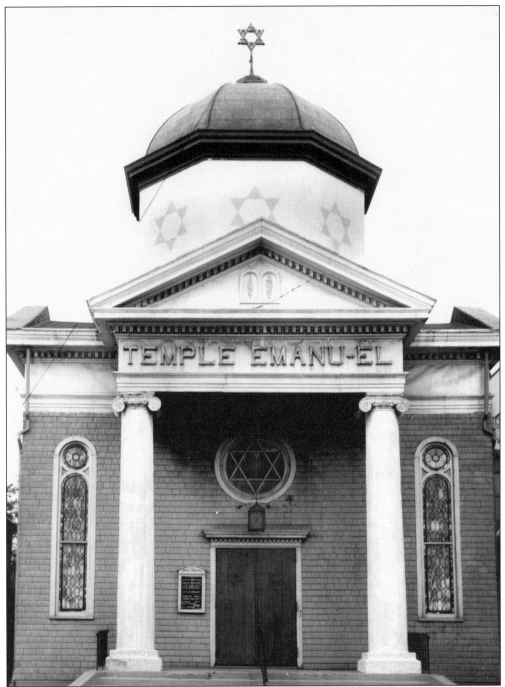

FIRST CONSERVATIVE SYNAGOGUE. Temple Emanu-El is the oldest synagogue building in continuous service on Staten Island. Architect Harry Pelcher sketched out a model conforming to the committee's wish to have a synagogue like Solomon's Temple. The cornerstone was laid by multimillionaire philanthropist Adolph Lewisohn in 1907. Julius Schwartz was the first president. Albert Goldfarb became the official cantor in 1910. For many years, an electric Jewish Star glowed from the top of the cupola. (Courtesy of Temple Emanu-El.)

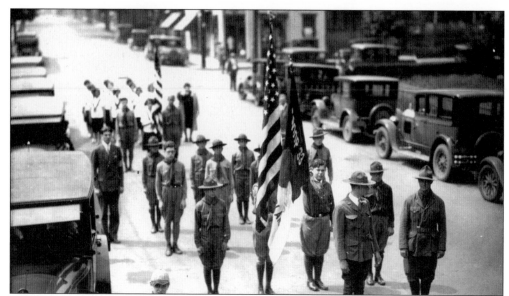

BRINGING IN THE FLAGS. At the opening of the dedication ceremonies in 1928 for the new education building of Temple Emanu-El, the Boy Scouts and Campfire Girls bring the flags of the United States and their troops to the outdoor dais in front of the steel framework of the building. (Courtesy of Temple Emanu-El.)

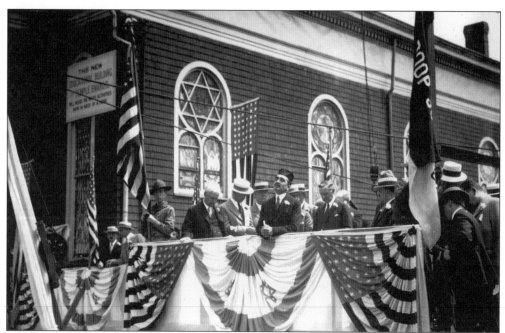

THE INVOCATION AND BENEDICTION. Rabbi Isaac A. Millner gives the invocation and benediction at the dedication of the education building. Born in Lithuania in 1875, Dr. Millner received a Doctor of Philosophy degree in Germany. Coming to the United States soon after, he obtained the degree of Doctor of Divinity from the Jewish Theological Seminary in New York City and became the spiritual leader of Temple Emanu-El in 1912. (Courtesy of Temple Emanu-El.)

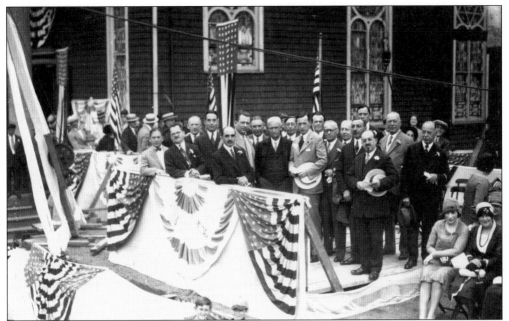

IMPORTANT MEMBERS AND HONORED GUESTS. The Honorable John H. Lynch, borough president; the Honorable Henry W. Bridges; Thomas C. Brown; J. Harry Tiernan; and Grover M. Moskowitz join Rabbi Millner; Charles Safran, president of Temple Emanu-El; Dr. George Mord, building committee chairman; Herman Schlesinger, dedication chairman; and several unidentified males on the main dais. (Courtesy of Temple Emanu-El.)

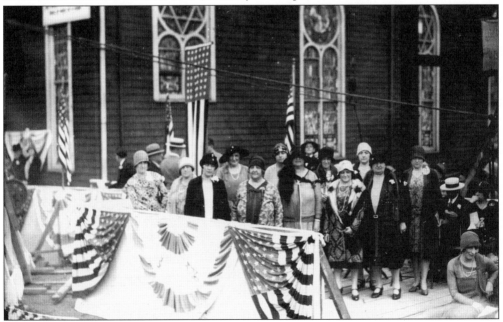

THE SISTERHOOD. President of the Sisterhood of Temple Emanu-El, Mrs. William Einziger, who gave an address from the main dais, is pictured here third from the left with ladies from the Sisterhood. Women sat on a separate dais to the side of the main dais. At this time there was still a clear separation of men and women. (Courtesy of Temple Emanu-El.)

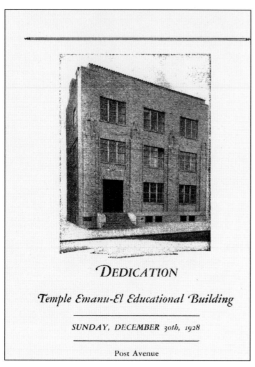

DEDICATION

Temple Emanu-El Educational Building

SUNDAY, DECEMBER 30th, 1928

Post Avenue

THE EDUCATION BUILDING. The construction of Temple Emanu-El's education building was a major event. Port Richmond was a thriving retail market, and the membership of the temple was thriving as well. No one could foretell that the Depression was around the corner and that the membership would have to dig deep into its pockets to pay off the mortgage. (Courtesy of Temple Emanu-El.)

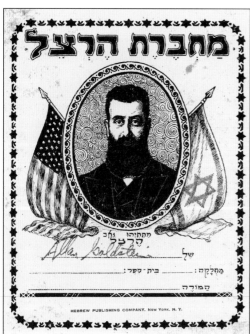

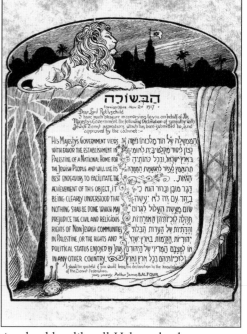

ALLAN GOLDSTEIN'S NOTEBOOK. The composition booklet, like all Hebrew books, opens to the right. It was used for learning to write the Hebrew alphabet. The patriotic front cover shows an image of Theodore Hertzl, the founder of Zionism. The back cover contains the historic 1929 Balfour Declaration on Palestine, the British protectorate that was divided into Jewish Israel and Arab Jordan in 1948. (Courtesy of Temple Emanu-El.)

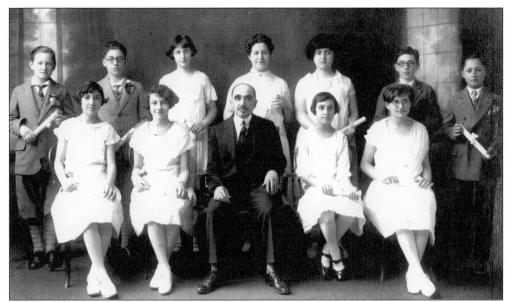

A CONFIRMATION CLASS. The confirmation class of 1933 is shown with Rabbi Millner, who had direct charge of the Hebrew school of Temple Emanu-El. Rabbi Millner was a member of the Rabbinical Assembly of the Jewish Theological Seminary of America, the Zionist Organization of America, and the Hebrew Benevolent Association. He was also active in the local Boy Scouts. The photograph was taken in a studio. (Courtesy of Temple Emanu-El.)

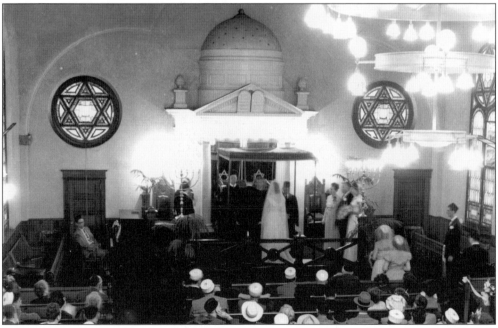

A WEDDING. Rosalie Horn and Jacob Brayman were married in the sanctuary of Temple Emanu-El in 1948. The reception was held in the beautifully decorated gym of the education building. Jewish weddings were not usually performed in synagogues, but since there were no Jewish banquet halls in Staten Island and the only kosher kitchens available were in synagogues, exceptions were made. (Courtesy of Rosalie and Jacob Brayman.)

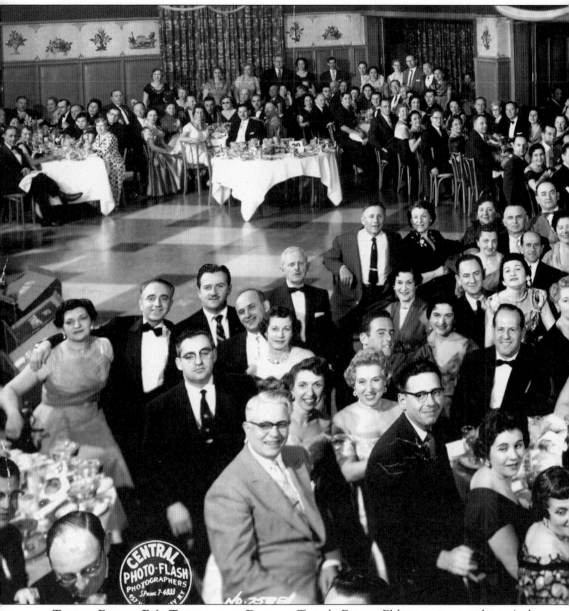

TEMPLE EMANU-EL'S TESTIMONIAL DINNER. Temple Emanu-El honors its president, Arthur Klein. Klein, a longtime member and president of the temple, was also involved in fund-raising for the Police Athletic League and the Staten Island Chamber of Commerce. Klein became

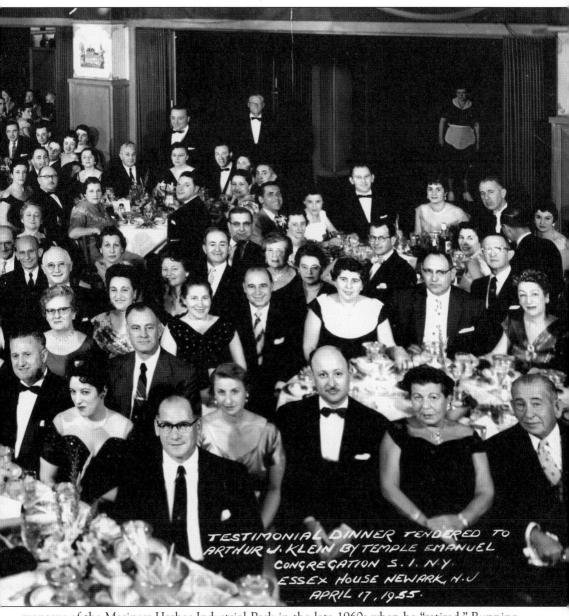

TESTIMONIAL DINNER TENDERED TO
ARTHUR J. KLEIN BY TEMPLE EMANUEL
CONGREGATION S. I. N.Y.
ESSEX HOUSE NEWARK, N.J.
APRIL 17, 1955.

manager of the Mariners Harbor Industrial Park in the late 1960s when he "retired." Running the industrial park of 28 businesses employing 800 people meant wooing new industries and ironing out problems faced by park tenants. (Courtesy of Monroe and Marcia Klein.)

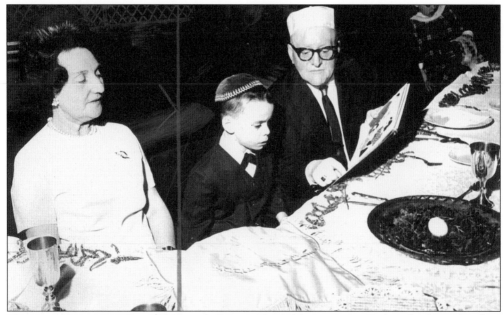

TEACHING PASSOVER. In 1966, Temple Emanu-El's Rabbi Benjamin Wykansky shows Stephen Garber the place in the Haggadah where, as the youngest male at the Passover *seder* (order of the feast), he must read the four questions in Hebrew. A graduate of Cambridge University, Wykansky was a rabbi in London and a British Army chaplain during World War II. He served as Temple Emanu-El's rabbi from 1951 to 1982 and was the recipient of many local and national awards and honors. (Courtesy of the *Staten Island Advance*.)

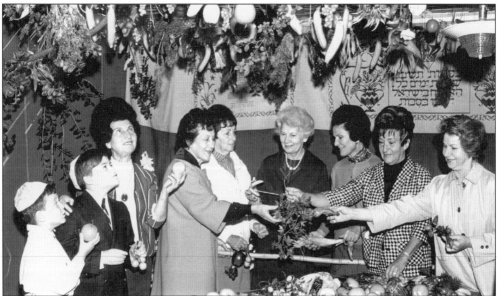

THE FESTIVAL OF SUCCOTH. Decorating the Succoth (Harvest Festival of the Booths) at Temple Emanu-El in 1968, from left to right, are Stuart Roaker, Raphael Adler, Rebbitzin Wykansky, chairwoman Mrs. Frank Radin, Mrs. Charles Luloff, Mrs. Irving Yoysh, Mrs. Abraham Baker, Mrs. Michel Schiffman, and Sisterhood president Mrs. Nathan Fine. (Courtesy of Ruth Baker.)

A CZECH TORAH. In the 1950s, 1,500 Torahs, stolen by the Nazis for a Museum of the Degenerate Jewish People to be erected after the Jews were exterminated, were discovered in Czechoslovakia. They were bought by an English citizen and stored in a Scroll Museum, but the ones too fragile to use were offered on permanent loan to interested synagogues. Kenneth Kane traveled to London to get one for Temple Emanu-El. (Courtesy of Channell Graham.)

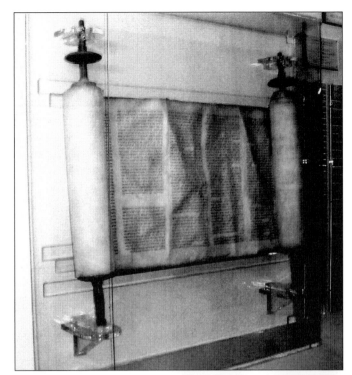

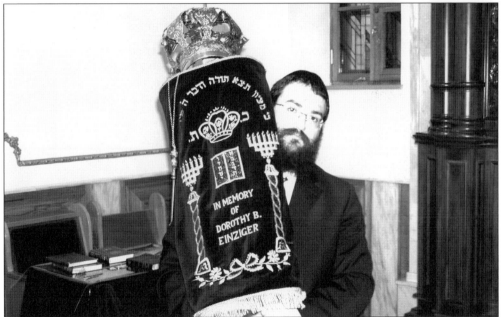

A TORAH FOR THE UKRAINE. Learning that a new congregation founded in the Ukraine after the fall of the Soviet Union needed a Torah, Harvey Fein, president of Temple Emanu-El, invited the synagogue's rabbi and two members of the congregation to Temple Emanu-El to receive a Torah as a gift. Rabbi Vishetsky sent this photograph to Temple Emanu-El, which shows him in the sanctuary of the Donetz synagogue holding the donated Torah. (Courtesy of Rabbi Yitchak Pinchas Vishetsky.)

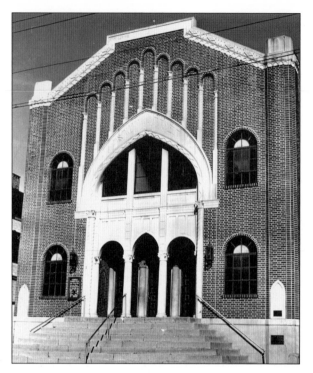

THE WRIGHT STREET SYNAGOGUE. Before Morris Sendar got people together to build Temple Tifereth Israel on Wright Street in 1916, Harry Toder went to a school called "Dr. Siegel's College" by local Jews and then to the Hebrew Alliance on Canal Street near Broad Street, where he was bar mitzvahed. There was even a makeshift shul above one of the stores on Bay Street for a short time. (Courtesy of the *Staten Island Advance*.)

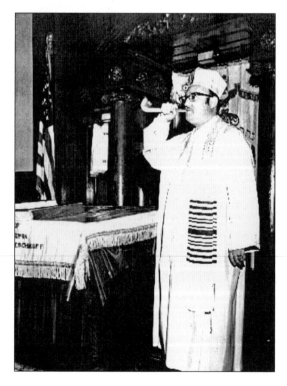

ROSH HASHANA. Rabbi Irving Brenner of Temple Tifereth Israel blows the shofar to usher in the Jewish New Year in September 1970. (Courtesy of the *Staten Island Advance*.)

TEMPLE TIFERETH ISRAEL TODAY. The Central Baptist Church is now housed in the building of the old Wright Street synagogue.

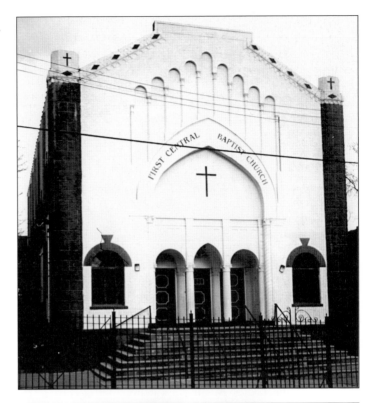

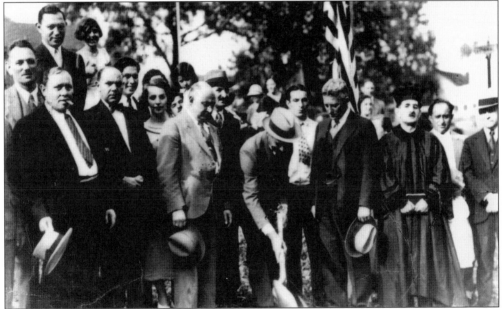

A SYNAGOGUE IN TOTTENVILLE. Breaking ground for a new building is a favorite recorded moment. An unidentified rabbi, dressed in the style of British rabbis at that time, was brought to the site to give the invocation and benediction. Congregation Ahavath Israel began meeting *c.* 1930, leasing space for services in a former American Legion hall on Main Street. This Amboy Road synagogue was erected in 1932. (Courtesy of Robert Baker.)

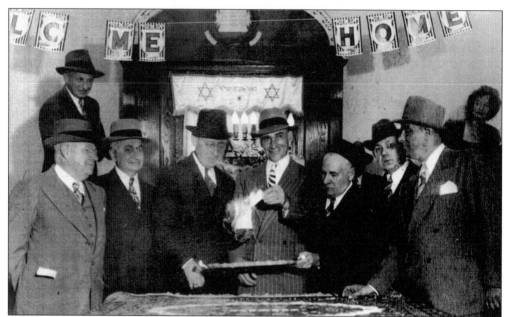

Burning the Mortgage. When the $1000 mortgage of the Tottenville synagogue was paid, a mortgage-burning ceremony was held in 1945 with the participation of five of the original organizers of the congregation. Shown here, from left to right, are Julius Getz, Julius Cohen, Barnet Schulman, ? Levenson, David Becker, ? Honig, and Abraham Goldberg. Mrs. Fried, president of the Ladies Auxiliary, watches in the corner. The man in the left corner is unidentified. (Courtesy of Robert Baker.)

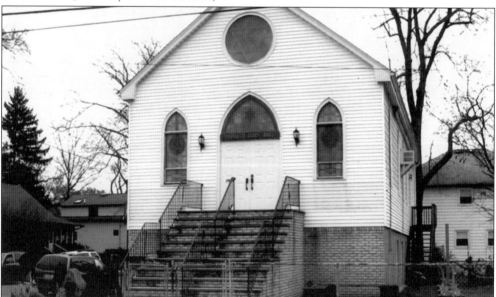

Ahavath Israel. For more than 50 years, the congregation benefitted from the leadership of Samuel Baker, longtime resident of Prince's Bay and owner of Prince's Bay Pharmacy, which is now run by his son Robert. Baker led Friday-night services and conducted bar and bat mitzvah services. Rabbis and cantors were hired only for High Holy Days. The congregation's very first full-time rabbi, Abe Unger, was hired in 2002. (Courtesy of Rabbi Boni Sussman.)

THE ONLY REFORM CONGREGATION ON STATEN ISLAND. Rabbi Jay Brickman of Temple Israel and Arthur Shapiro study in the American Legion hall. The large slate blackboard is from a school. Many congregations started small. They met in homes and rented spaces in churches, Masonic temples, and American Legion halls until they were large enough to build their own synagogues. The Reform congregation went through a similar process from 1947 to 1967. (Courtesy of Temple Israel.)

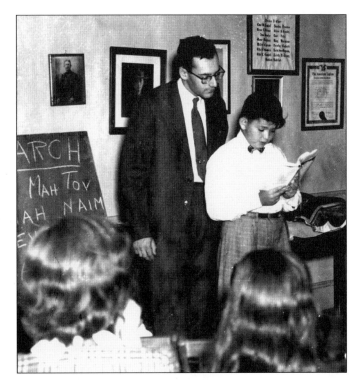

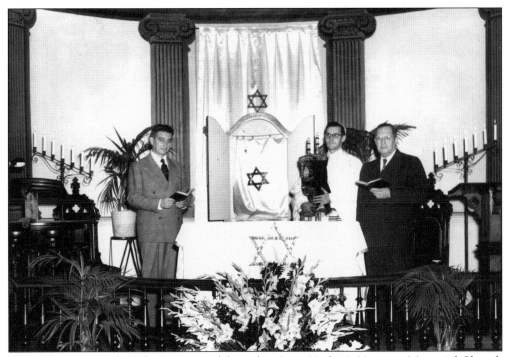

SNUG HARBOR. High Holy Days are celebrated in Snug Harbor's Veterans Memorial Chapel. Pictured here, from left to right, are vice president Joseph Werb, Rabbi Jay Brickman, and president Dr. David Machol. (Courtesy of Temple Israel.)

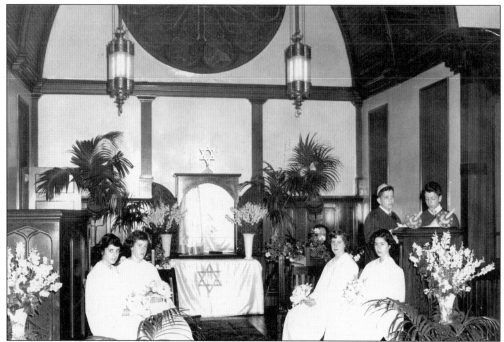

THE UNITARIAN CHURCH. Attending the first Temple Israel confirmation class held in the Unitarian church, from left to right, are the following: (seated) Carolyn Joan Kahn, Carole Ann Marks, Jacquelin Adel Werb, and Ruth D. Levy; (standing) Gilbert David Cooke and Arthur Shapiro. (Courtesy of Temple Israel.)

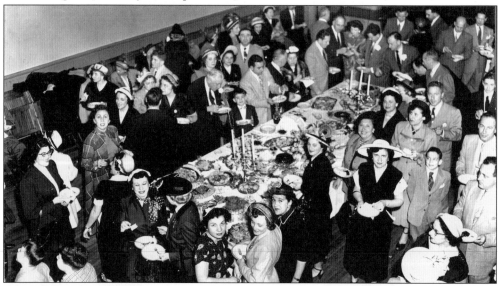

A BAR MITZVAH AT THE CHURCH. Temple Israel's congregation celebrates the bar mitzvah of Maurice Usland in 1951 with a buffet reception in the social hall of the Unitarian church. Big bar mitzvah receptions resembling weddings—with a dance band, a master of ceremonies, hors d'oeuvres, cocktails, and a full sit-down dinner—became popular in the late 1950s. Since there were no Jewish catering halls on Staten Island, families generally utilized whatever large space was available to satisfy the needs of their congregation. (Courtesy of Temple Israel.)

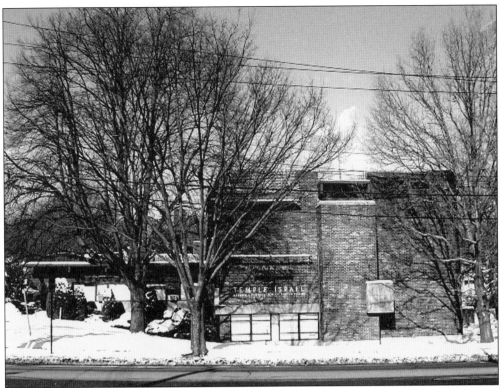

Temple Israel. A creek running through the property on Forest Avenue in Randall Manor prevented this municipal corner lot from being used for residential purposes, but fortunately for the congregation, the lot was approved for a religious institution. Temple Israel was designed by Percival Goodman, a leading modernist architect who designed award-winning synagogues throughout the United States. The temple, which opened in 1967, is handsomely sited and landscaped. (Courtesy of Channell Graham.)

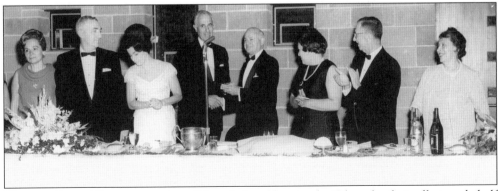

Home at Last. The congregation of Temple Israel honors the Tilzers for their efforts on behalf of its new home. From left to right are Inga and Jules Avins, Gloria and Ira Tilzer, Morris Singer, Harriet and Rabbi Marcus Kramer, and Ida Singer. (Courtesy of Temple Israel.)

43

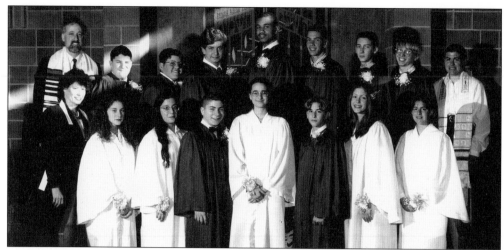

CONFIRMATION AT TEMPLE ISRAEL. Shown here, from left to right, in the first row, are Arlene Andelman, Shari Gross, Gillian Ricci, Josh Baver, Alyssa ?, Gabe Scher, Karen Chernoff, and Jaime Colon. The second row includes Rabbi David Katz, Phillip Marks, Michel Myerson, Eric ?, Jacob Himmelstein, Gary Mason, Bernard Braun, and Cantor Suzanne Bernstein. (Courtesy of Temple Israel.)

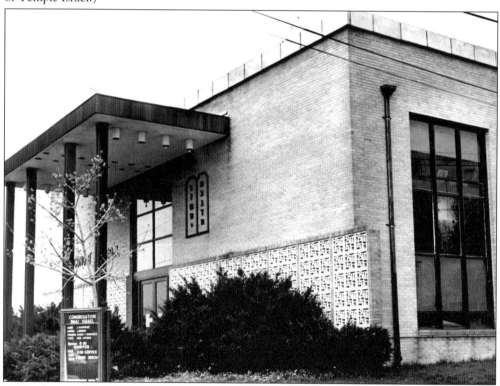

B'NAI ISRAEL. B'nai Israel opened in Bay Terrace in 1968. Originally on Bancroft Avenue in Grant City, the congregation was forced to give up its property due to the expansion of the Staten Island Rapid Transit System. For four years, the congregation wandered about holding services in empty stores, tents, congregants' homes, and the New Dorp Baptist Church, where services were held without a fee. (Courtesy of the *Staten Island Advance.*)

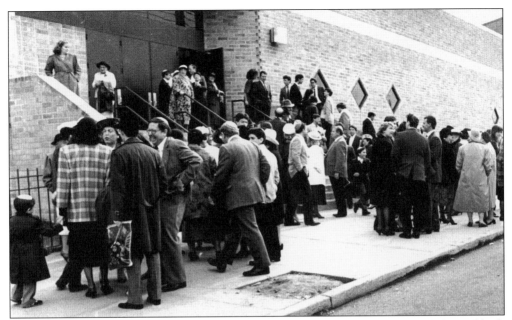

YOUNG ISRAEL OF STATEN ISLAND. Members congregate outside the synagogue after Sabbath services. The community mikvah is located at Young Israel. The center of the Orthodox community, it is the largest congregation on Staten Island. Led for many years by Rabbi Jay Marcus, it is now led by Rabbi Yaakov Lehrfield. (Courtesy of the *Staten Island Advance*.)

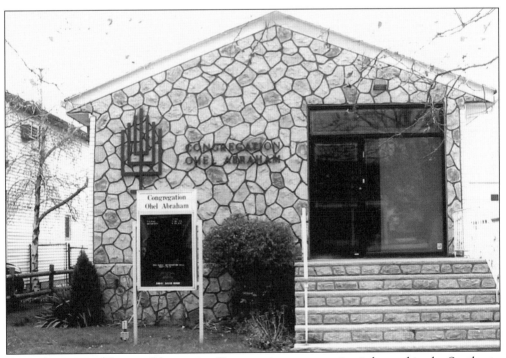

OHEL ABRAHAM. This small but active Conservative congregation is located in the Southgate area of Mariners Harbor in Graniteville. Active in all areas of community life, Ohel Abraham is led by Rabbi Andy Eichenholz. (Courtesy of Rabbi Boni Sussman.)

OR HACHAIM SEPHARDIC CONGREGATION MIDRASH DAVID. This small building is used by the Willowbrook Sephardic congregation. Note the dismantled bamboo poles with which a Succoth had recently been erected.

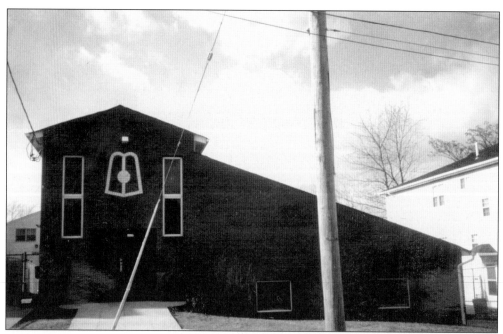

AGUDAH ISRAEL BAIS ELEIZER. A learned and observant congregation, Agudah Israel Bais Eleizer is part of the worldwide Agudath Orthodox movement. The charismatic Rabbi Moshe Meir Weiss is a noted teacher of Daf Yomi and a lecturer on family matters. Daf Yomi, meaning "Daily Page," is a Torah study program in which the same page of the Torah is read and discussed by Daf Yomi Jews all over the world.

46

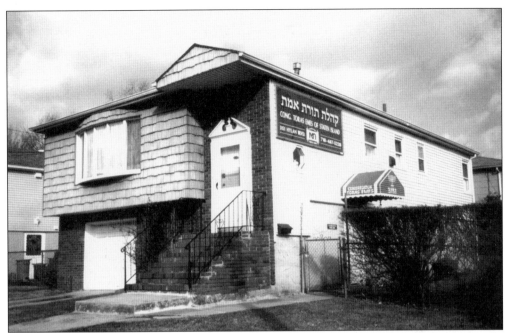

TORAS EMES. Like many small Staten Island synagogues, Toras Emes, in Oakwood, fits into the neighborhood in an unassuming way. Local Russian Jews send their children to the synagogue's Hebrew classes.

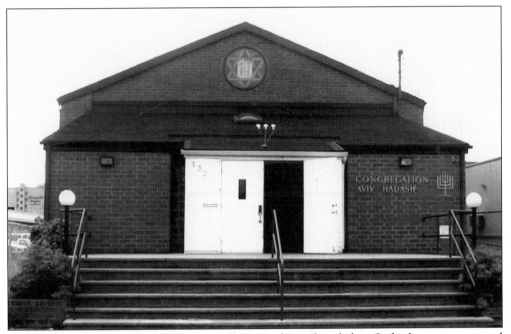

AVIV HADASH. In New Springville, a small group of Jews founded an Orthodox synagogue and joined two trailers together for a sanctuary. Two years later, another group of Jews founded a Conservative synagogue, Aviv Hadash, but had no building. They merged in 1982 and are now called Aviv Hadash. (Courtesy of Rabbi Boni Sussman.)

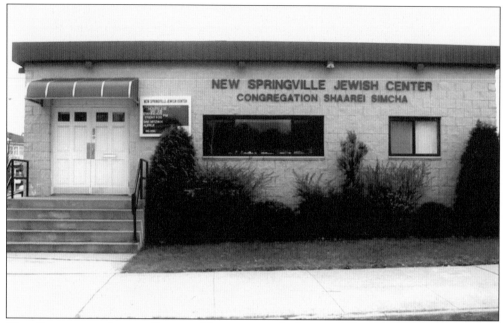

NEW SPRINGVILLE JEWISH CENTER. The center is the home of Sharei Simcha. Other Staten Island congregations not pictured are Rabbi Shulman's Beth Yehuda, which has the latest weekday service on Staten Island; Aviv Chadash, a Conservative congregation; and Bais Menachem Chabad Lubavitch.

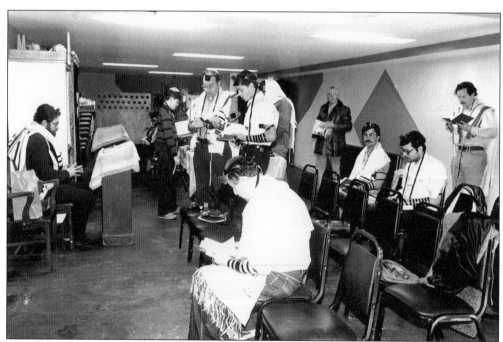

SHAREI SIMCHA. This Orthodox congregation is led by the charismatic Rabbi Nate Segal. It has attracted many Israelis and also non-practicing former Orthodox Jews who are returning to Judaism through the work of the congregation. (Courtesy of the *Staten Island Advance*.)

48

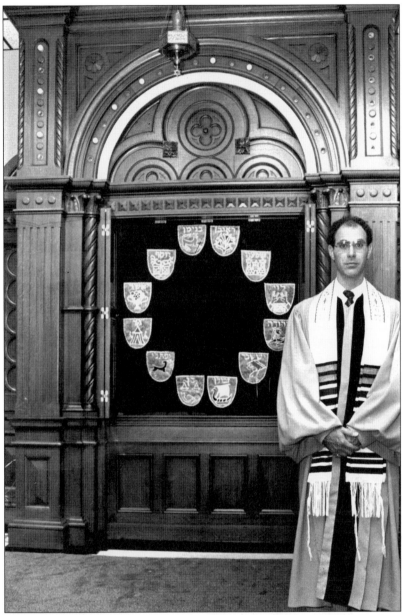

THE PRECIOUS TORAH ARK. Rabbi David Goldstein of the Arden Heights-Boulevard Jewish Center stands in front of the ark, newly acquired through the efforts of former congregant David Dennenberg. The ark, more than 100 years old and made of hand-carved oak, survived a fire that destroyed its original home, the Elm Street Shul in Chelsea, Massachusetts, in the early 1970s. It was discovered at the Chelsea Yeshiva 10 years later. Congregation Etz Chaim, the first house of worship for the members of the Arden Heights-Boulevard Jewish Center, was located in the Woodrow Community Center. In 1975, the group moved into a former farmhouse on Arthur Kill Road. Groundbreaking ceremonies for a new temple were held in 1977 on the South Shore. A young, family-oriented Conservative synagogue, its membership of 200 families comes from Arden Heights, Annadale, Huguenot, Eltingville, and Great Kills. (Courtesy of the *Staten Island Advance*.)

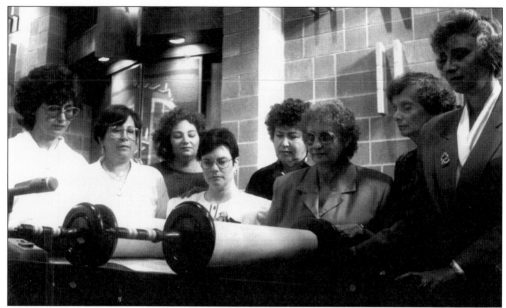

WOMEN AND THE TORAH. Members of Temple Israel studying the Torah scroll, from left to right, are Beverly Mazer, Judith Pessah, Susan Marks, Linda Brill, Eleanor Nallit, Ada Kadin, Dianne Eisenkraft, and Anita Cohen-Ulberg. (Courtesy of Temple Israel.)

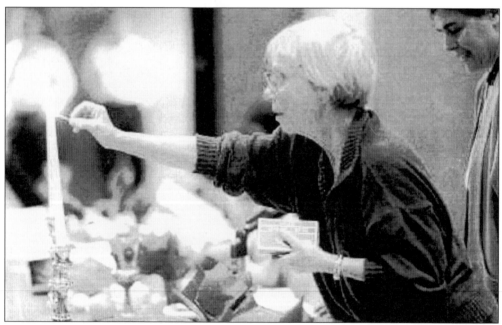

THE FIRST WOMEN'S *SEDER*. Livingston resident Jenny Tango lights the candles in Temple Israel. At right is Suzanne Bernstein, Staten Island's first and only female cantor. Rebbitzin Boni Nathan Sussman of Temple Emanu-El and Cantor Suzanne Bernstein of Temple Israel combined forces to introduce the first women's *Seder* (the order of the ceremonial dinner commemorating the Exodus from Egypt) to Staten Island in 1997. Fifty-three women attended. (Courtesy of the *Staten Island Advance*.)

Three

BEING BURIED IN A JEWISH CEMETERY

. . . and buy another grave site so we can all be together in death.
Last Letter from my Beloved Father (Moses Greenwald to his son Abraham)

—Jane Aberlin, *Seniority Rules*, 1998.

The first action of a congregation is to purchase a Jewish burial ground. Due to a law in 1865 prohibiting new burials in Manhattan, cemeteries moved outside of its boundaries. Abraham (d. 1887) and Rachel (d. 1894) Almstaedt of Staten Island were buried in a family plot in Queens. The Hebrew Free Burial Association (HFBA), formed by a small group of men on the Lower East Side in 1888, raised the money to buy a small space on Staten Island, which became Silver Lake Cemetery, and to bury those Jews who could not afford the cost of funerals and plots. The *mitzvah* (blessing) of a burial in the Jewish tradition is a sacred task and is made obligatory upon every person in the Jewish community in the case of a *met mitzvah* (a dead person without family). Most of those buried were immigrants who lived in the New York Jewish ghettoes. Burials began in 1892 in Silver Lake, the oldest Jewish cemetery on Staten Island. When the first cemetery was filled, the HFBA raised money to buy a second, Mt. Richmond Cemetery, in 1909. It is still in use today.

In Mt. Richmond Cemetery lie the young Jewish immigrant women killed in the Triangle Shirtwaist Fire of 1911, American servicemen, Holocaust survivors, Soviet Jews, Ukraine's Chernobyl disaster victims who came to the United States for treatment, the homeless, AIDS patients, those who committed suicide, those who died in nursing homes, and children who died before they had a chance to live. The HFBA has interred more than 55,000 Jews in its two historic Staten Island cemeteries and is the largest free burial agency in the Diaspora, laying to rest more than 400 people annually.

Burials in the Baron Hirsch Cemetery date back to 1899. The grandfather of Ronald Gresser, owner of Gresser Monumental Works in Graniteville, was the original superintendent at Baron Hirsch. It is the cemetery most used by the "before the bridge" members of the Staten Island Jewish community. The United Hebrew Cemetery, abutting the Mt. Richmond Cemetery, is located at 122 Arthur Kill Road. Its earliest known burial was in 1908. As of 2003, it has provided over 32,000 burials. These cemeteries are open to burials of all Jews, not only those from Staten Island.

Funeral homes have taken over the functions that were formerly the responsibility of the family or the local burial society. Until Menorah Chapels opened on Victory Boulevard in 1981, Jewish families used local funeral homes that met Jewish burial standards.

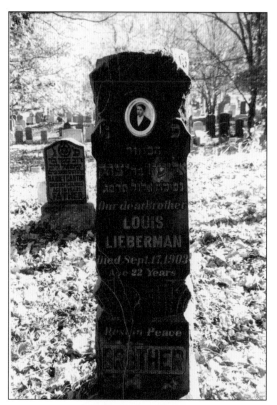

SILVER LAKE CEMETERY. Staring out of photographs mounted on weather-worn tombstones are young men and women: fathers, mothers, sons, daughters, brothers, and sisters whose lives were ended by overwork and disease. A monument in the form of a tree stump was often used for teenagers and young people who were "cut down" before their time.

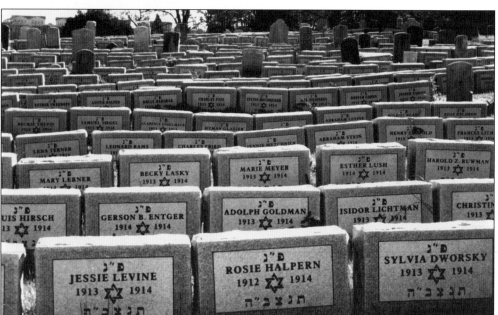

THE INFLUENZA EPIDEMIC. Burials at Mt. Richmond Cemetery peaked at 1,261 in 1914. More than half of these burials were children carried off by the influenza and diphtheria epidemics sweeping the tenements. The Make Your Mark Campaign, started in 1985, supplied the granite markers for the graves of infants whose families were too poor to afford a monument.

THE ALBANIAN BURIAL SOCIETY. Jewish immigrants from different European towns organized burial societies for the purpose of purchasing plots in Jewish cemeteries. Jews shared hardships in the old country, had come to the United States as a group, lived near each other, helped each other, and intended to be buried together. Burial societies were social gathering places. Banquets were held every year, providing the women a chance to get together to cook and exchange news. This photograph was taken in Baron Hirsch Cemetery.

CEMETERY MAP. This is just a small section of Baron Hirsch Cemetery. Originally, the cemetery's location was rural and mostly uninhabited. At present, an active four-lane avenue and various single and two-family housing developments surround it.

JERSEY STREET
MENASSE LODGE
D'SLONIM
STANISLAVER
BACHUER
STOLOWITZER
S.I. Lodge Jersey St.
MUSHNIKER
BREITBART
WOLF ABRAMOWITZ
ANTIPOLER
ACHUSOS NACHLO

CHERNOBILER
PRAILER BESS. NOVOSELITZER FAMILY PLOTS
S.I. LODGE O.G.
RIGA LODGE
BOTOCHANER LADIES
YOUNG HUNGARIAN

UNITED STATE LODGE
KOLBUZOWER
Tem. Em. Port Rich.
Heb. Star Bay. Lodge
BAY. IND. HEB.
1st YASSIER
Temple Em. Port Rich.
Temple Em. Port Rich.
Las- Suss- Weis- Kut- Kut- Kut-
ker kind glas chercher cher
EMP. of S.I. Doubowsky
TEMPLE EMANUEL OF S.I.

ROSENO
HABER
SEILER
GRODBERG
FRIEDMAN
KLIPSTEIN
BRIMBERG
SIMON
FINKELSTEIN
MILLER
WEINGART
GREENBLAT
TROHH
WEISS KAHN
HANDEL
WEISS
KLEIN
SEWELL
NORD

KANDEL
MENDELSOHN
SKOTCH
SIGAL
GOODMAN
YUSSIM
SCHIFF
HELLER
GOOTEMBERG
SONER TEICH
NEWMAN RICH
RADIN ABELS
ZILBERSHER
KLAUBER
WEISS NEWMA
PARISH
DEKORN
EINZIGER

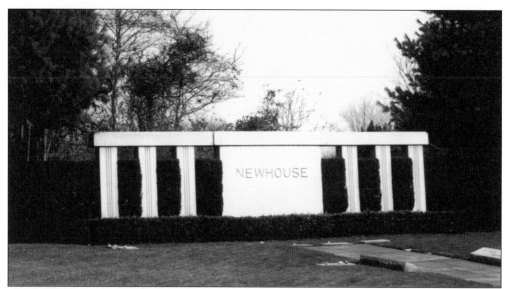

THE NEWHOUSE FAMILY. The spacious Newhouse family plot has plain, flat markers for deceased members of the family. It is simple with an iron-gate fence in front and a central path. So many members of the Jewish community have been buried at Baron Hirsch Cemetery, it could be the setting for a Staten Island *Our Town*.

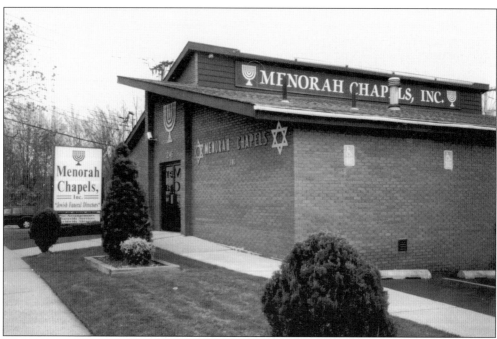

THE FIRST AND ONLY JEWISH FUNERAL HOME. Until Menorah Chapels opened in 1981, Jews on the North Shore used Cassidy and Sylvie Funeral Homes. Menorah Chapels bought the property in 1977, but it took three years of dealing with various legal, civic, and real estate regulations to finally get permission to build a Jewish funeral home on Richmond Avenue.

A Town Died. Some towns in Poland were 80 to 90 percent Jewish. Whole Jewish towns were emptied into death camps. Holocaust Memorials like this one at Baron Hirsch Cemetery have been erected in Jewish cemeteries all over the United States by their American *landsleit* (townsfolk). Side views of the monument are shown below.

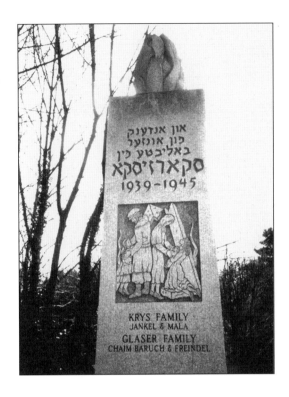

און אנדענק
פון אונזער
באליבטע קין
סקאַרזיסקאָ
1939-1945

KRYS FAMILY
JANKEL & MALA
GLASER FAMILY
CHAIM BARUCH & FREINDEL

Families Perished. The names of townsfolk who were murdered by the Nazis are listed on this obelisk memorial erected by surviving members of the Krys and Glaser families at Baron Hirsch Cemetery.

DEFACED MEMORIALS. Photographs on old Jewish tombstones seem to attract vandals. Somehow, despite the scratched visage, this old bearded man's face on this heavy, crude tombstone in Hebrew Union Cemetery speaks to visitors of an earlier observant period.

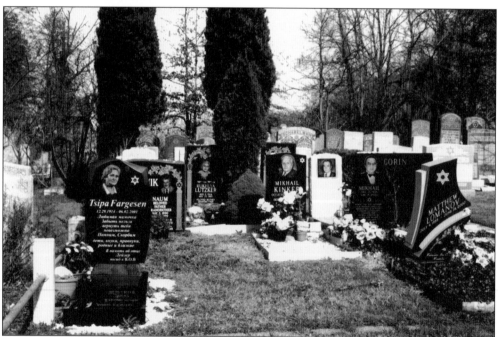

RUSSIAN TOMBSTONES. Since the Iron Curtain first opened to permit Soviet Jews to emigrate, Russian graves have begun to appear in Baron Hirsch Cemetery as well as in the other Jewish cemeteries on the island. Whereas old Jewish tombstones had Hebrew inscriptions, Russian tombstones, often black or red granite with portraits photo-etched in the stone, bear Russian inscriptions.

56

Four

EARNING A LIVING

*In 1859 one could buy anything from shoes to saddles in Stapleton, while masons,
window shade makers, tinsmiths, ice makers, engineers, surveyors,
florists, and plumbers all successfully plied their trade.*

—Patricia M. Salmon,
Stapleton: A Community of Contrast and Change, 2002.

The main economic base of Staten Island up to the late 1880s was fishing and farming. None of the industries on Staten Island, not even the Jewish-owned firms of the Monroe Eckstein Brewery, the Dreyfus Company, Weissglass Dairy, Richmond Floral Company, and the *Staten Island Advance*, offered employment opportunities for large numbers of Jews. Early Jewish immigrants were mostly craftsmen and small independent shopkeepers, some of whom started out as peddlers. Among the first Jewish businesses were confectioneries, clothiers, and dry goods stores. By the late 1890s, the first generation of college-educated Jews had gone into dentistry, medicine, and law. Dr. George Mord was medical examiner for Richmond County, Abram Greenwald was a tax collector for Northfield, and Elias Bernstein was counsel to the sheriff of Richmond County and, later, a judge. Julius Weissglass and his father, Max, immigrants from Poland, bought a farm on Rockland Avenue in Egbertsville for $500 in 1897. Julius sold eggs and chickens to Jewish families on Jersey Street.

Jersey Street in New Brighton was Staten Island's first major shopping area. The trolley line along Jersey Street ran past kosher butchers, Chinese laundries, Polish delicatessens, Italian barbers, and a synagogue. One could buy everything from a uniform to a live chicken. In the 1920s, there was a spurt in the number of Jewish and Italian businesses on Richmond Avenue, in Port Richmond, which was fast becoming "the Fifth Avenue of Staten Island." Charles Harry Moses, with his brothers Lewis and Elias, built movie houses all over the island. Dr. Mendel Jacobi served as assistant medical examiner.

The Depression saw large companies shut down and many small stores on Staten Island close. The Jewish community struggled to maintain its new community center and to pay the mortgages on its synagogues, and through dint of will and sacrifice, succeeded. More and more, educated Jewish men and women turned to jobs in the public sector. In the 1950s, the ubiquitous automobile made the inland areas of the island more accessible. People and businesses began moving off Jersey Street. Richmond Avenue businesses could not compete with the Staten Island Mall built in New Springville in the 1970s.

Today, there are no longer any kosher butchers on Jersey Street. Kosher meat is mostly delivered from Brooklyn or New Jersey. The Dairy Palace Pizzeria, Kosher Island Take-out, Yum-Yum Chinese Take-out, Famous Bakery & Grocery, Delicious Grill, Good Appetite Dairy Restaurant, and Carmel Bookstore, situated next to each other in Willowbrook, comprise a small Jewish market on Victory Boulevard across from the large Catholic Alba House complex.

RICHMOND TURNPIKE. A policeman stands on the corner of Richmond Turnpike in Tompkinsville. In 1898, under consolidation, the 66 policemen in the Richmond County Police Force became part of the New York City Police Department. On the other side of the bay is Brooklyn. Richmond Turnpike was renamed Victory Boulevard after World War I. This scene was photographed by Isaac Almstaedt *c.* 1900. (Courtesy of the Staten Island Historical Society.)

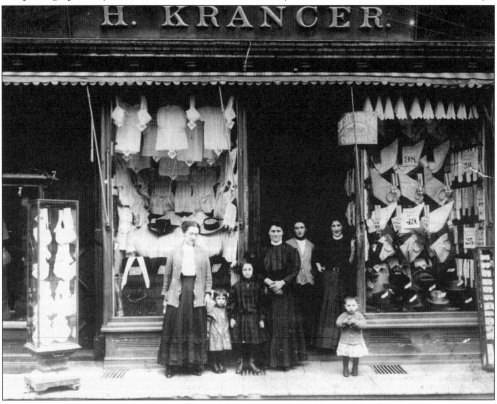

H. KRANCER. Standing in front of Krancer Dry Goods *c.* 1884, from left to right, are Aunt Becky Steinberg, Isaac "Sonny" Steinberg, an unidentified girl, two unidentified women, Yetta Krancer Susskind, and her son Isaac Susskind. Note the wooden plank sidewalk. (Courtesy of Edith Rivkin Susskind.)

58

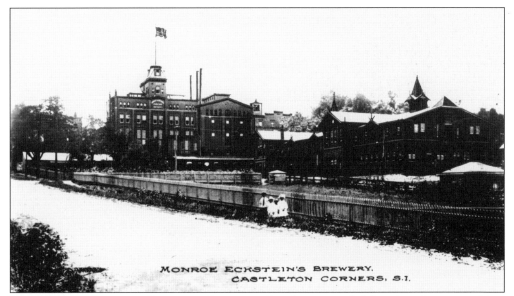

THE MONROE ECKSTEIN BREWING COMPANY. Bernheimer and Schmid vaults were sold to Fenzel and Decker in 1865. In 1867, the vaults were purchased by Joseph Setz, who then sold them to Monroe Eckstein of West New Brighton in 1875. In 1890, the business was incorporated as the Monroe Eckstein Brewing Company. At Eckstein's death in 1895, his brother Samuel took his place. The beer brewed was lager. (Courtesy of the Staten Island Historical Society.)

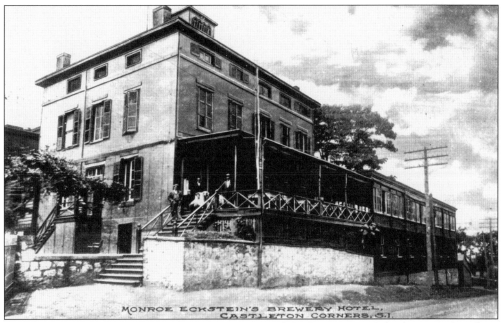

THE MONROE ECKSTEIN HOTEL. It was not unusual for brewing companies to run hotels or sponsor saloons. Monroe Eckstein was one of the organizers of the Richmond County Savings Bank in 1886 and acted as its first president. (Courtesy of the Staten Island Historical Society.)

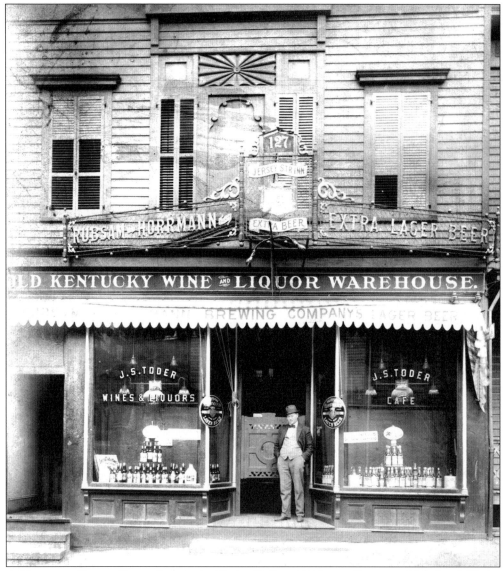

A NICKEL A GLASS. Shown here is the Toder Café at 127 Jersey Street in 1908. Jacob Toder came to the United States alone at the age of 14 from Austria in the late 1890s. As a young man, he left his job in a Newark saloon for a better job at a Buick agency on Staten Island. When he saw an empty store next to Rubcam & Hormann's Brewery, he made an exclusive deal with the brewery to sell its beer, and the brewery furnished all the café equipment. Toder did so well that he bought a house on Crescent Avenue one block from Jersey Street. It was a wooded area then, and when his little son Harry got lost among the trees, the whole family had to look for him. Toder closed his café because of Prohibition. Although he was advised to keep a non-alcoholic café up front and have a speakeasy with a backdoor entrance, as did many others, he refused to break the law. When Prohibition was repealed, he opened another bar with an Italian partner and, after a few different bars, retired. None of his three sons was interested in carrying on the business. (Courtesy of Harry Toder.)

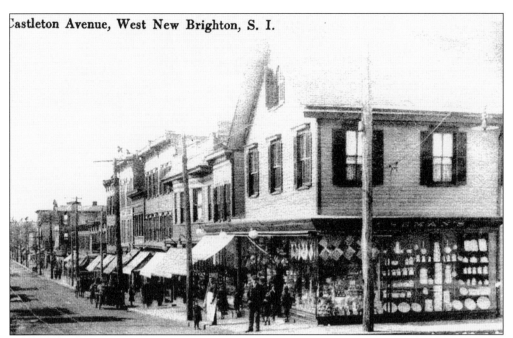

CASTLETON AVENUE. Jersey Street businesses overflowed onto the wider Castleton Avenue in the direction of Port Richmond. The Richmond Savings Bank, Hook and Ladder No. 79, the *Staten Island Advance*, the S. R. Smith Infirmary, and St. Vincent's Hospital were all located on Castleton. (Courtesy of the Staten Island Institute of Arts and Sciences.)

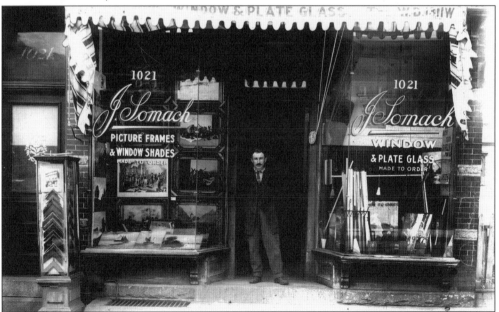

FROM CRAFTSMAN TO SHOPKEEPER. Joseph Somach stands in front of his store in New Brighton *c.* 1910. Joseph, his wife, Molly, and their two-year-old son, Israel, came to the United States from Vilna in 1905. Starting out with a borrowed horse, a piece of glass, and $25, Joseph became successful enough to open a store. His great-grandson Jeffrey runs Somach's on Richmond Road. (Courtesy of Lawrence Robert Somach.)

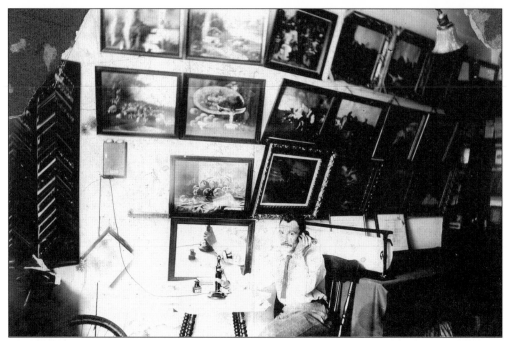

ARTS DEALER. Joseph Somach is seen here inside his store. Local telephone service was available as early as 1879. The motto for Somach Window Shade Company was "Just a Shade Better." (Courtesy of Lawrence Robert Somach.)

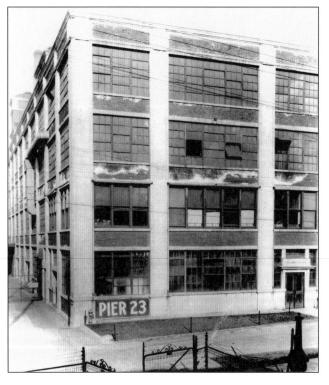

PIER 23. In 1909, Dr. Louis A. Dreyfus founded the L. A. Dreyfus Company, a gutta-percha refining factory on Maple Avenue in Rosebank. The company moved to Pier 23, in Clifton, to facilitate the import of crude gutta-percha. One of its by-products was chicle. The Dreyfus electric Wrigley Gum sign on the roof of its building was the first electric sign on Staten Island and was familiar to every ferry commuter. The plant later relocated to Edison, New Jersey. (Courtesy of the Staten Island Historical Society.)

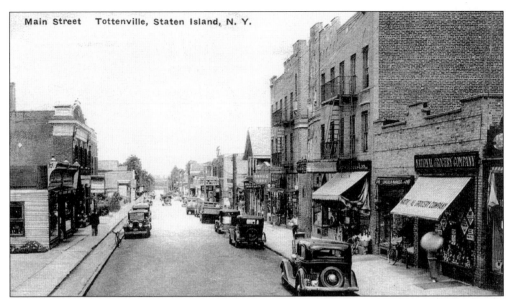

TOTTENVILLE. On the right side of Main Street is the Stadium Movie Theater. At the southernmost end of Staten Island, Tottenville was a small thriving town with a Jewish community large enough to support a synagogue but not a rabbi. Tottenville was connected to New Jersey by the Perth Amboy Ferry. The Outerbridge Crossing Bridge opened in 1928; nevertheless, ferry service continued until 1963. (Courtesy of the Staten Island Institute of Arts and Sciences.)

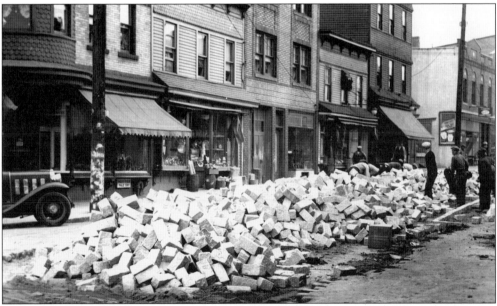

BRICKING JERSEY STREET. Dirt roads were no longer adequate for the bustling Jersey Street. Known as "Burma Road," Jersey Street had 125 businesses, 20 private homes, and several small apartment houses. In 1938, an 1869 factory on Jersey and Richmond Terrace, which had been converted into apartments, collapsed during a torrential rainfall due to the water overflow from culverts running underneath. Eighteen people lost their lives. Mayor Fiorello LaGuardia gave an address atop the rubble. (Courtesy of the *Staten Island Advance.*)

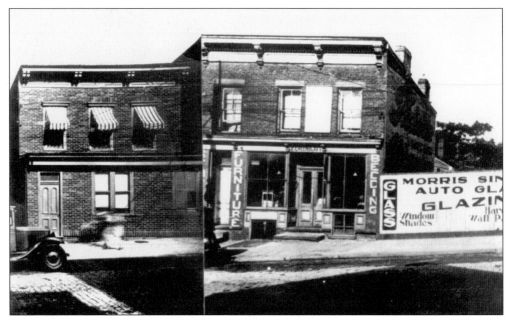

JERSEY STREET. Two doors to the left of the Greenblatt Furniture Store was a live poultry market. African Americans resided at both ends of Jersey Street. Jews, Poles, Italians, and Irish lived above the stores. (From *New Brighton Lives,* by Colin Reed, 2000, with permission from the author.)

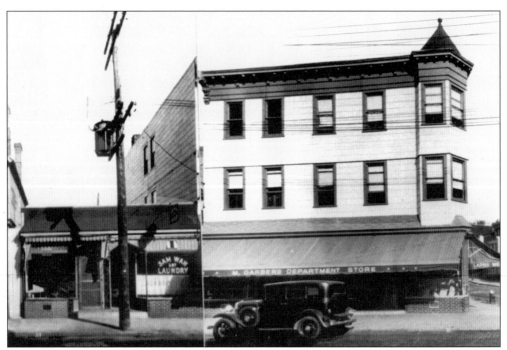

GARBER'S DEPARTMENT STORE. Men's and boy's clothing could be bought on time at Garber's Department Store. There were six Chinese laundries on Jersey Street. (From *New Brighton Lives,* by Colin Reed, 2000, with permission from the author.)

MORRIS SINGER HARDWARE. Beside Morris Singer Hardware was a soda fountain. Lieblich's (not shown) on the corner of Brighton Avenue was a Jewish bakery that made "the best pumpernickel, rye bread, and Kaiser rolls." (From *New Brighton Lives,* by Colin Reed, 2000, with permission from the author.)

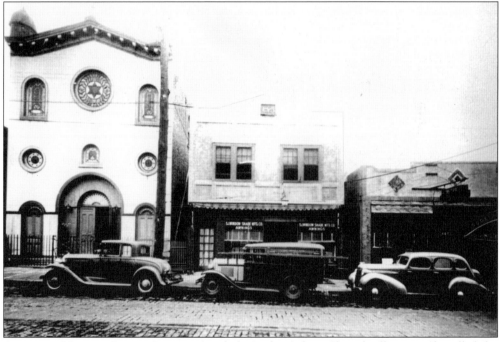

ANOTHER VIEW OF JERSEY STREET. Agudath Anshe Achim Chesed, affectionately called the Jersey Street Shul and later "the Triple A," was next to the Staten Island Window Shade Manufacturing Company and Gugliucci's Undertakers. (From *New Brighton Lives,* by Colin Reed, 2000, with permission from the author.)

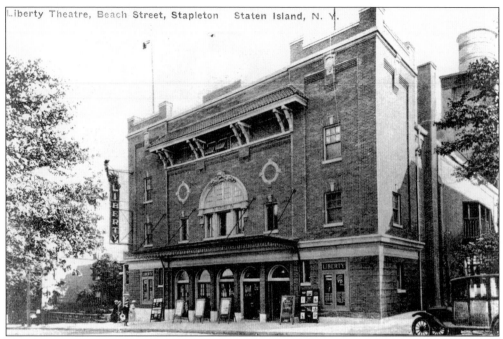

Liberty Theatre, Beach Street, Stapleton Staten Island, N. Y.

THE LIBERTY THEATER. Charles Harry Moses purchased the Bijou Theater when there were only five theatrical houses on Staten Island. Later, he and his brothers formed the Isle Theatrical Corporation, taking over the Richmond and Park Theaters and building the Liberty in Stapleton (above), the Ritz in Port Richmond, the Strand in Great Kills, and the Stadium in Tottenville. The Liberty opened in 1918 with the drama *Very Good, Eddy.* Although it played movies, the theater, seating 1,500, was known for its shows. (Courtesy of the Staten Island Historical Society.)

KNIGHTS OF PYTHIAS. Jewish businessmen and professionals belonged to mostly Jewish lodges of Masons, the Order of Elks, the Knights of Pythias, the Lions Club, and the Rotary Club. The Aquehonga Lodge No. 906 was formed in 1913 with a membership of 28 Jewish Master Masons. The Knights of Pythias did charitable work, bowled together, and socialized at Klegan's. (Courtesy of Joel Cohen.)

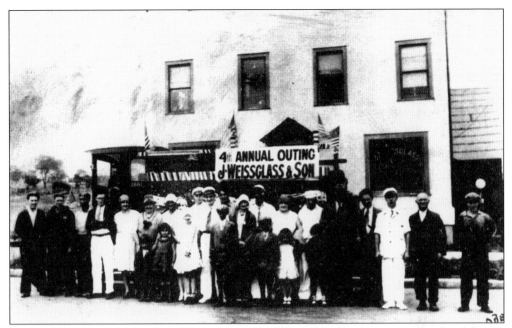

WEISSGLASS DAIRY'S ANNUAL OUTING, 1929. Weissglass drivers never missed a delivery. When floods hit Oakwood and Midland Beach, milk was delivered by rowboat. (From *Smiling Over Spilt Milk*, by Charles Weissglass, with permission from Alan Weissglass.)

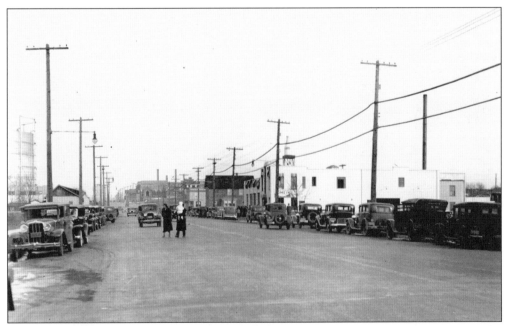

WEISSGLASS PASTEURIZING AND BOTTLING PLANT, 1933. Note the big milk bottle on the roof of the plant. At this time, Weissglass milk sold for 12¢ a quart and was delivered right to the customer's doorstep. A fire destroyed the plant in 1972, and the company soon went out of business. One of the Weissglass horse-drawn milk wagons is on exhibit at the Richmond Town Village Museum. (Courtesy of the *Staten Island Advance*.)

WEISSGLASS & SONS. Weissglass became Weissglass & Sons in 1933. Seen here, from left to right, are Julius, Oscar, Charles, and Joseph Weissglass. As children, the three sons rose at 2 a.m. to deliver the milk. A loving, hardworking family, the Weissglasses have had a major role in Staten Island, as well as in the Jewish community. (From *Smiling Over Spilt Milk*, by Charles Weissglass, with permission from Alan Weissglass.)

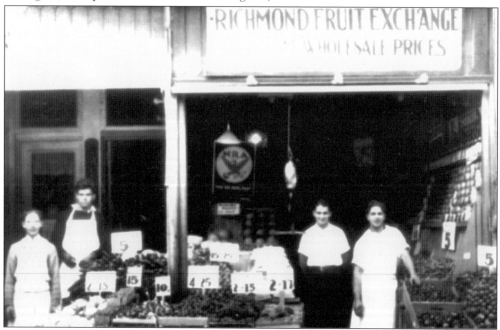

RICHMOND FRUIT AND VEGETABLES. "Staten Island," an earlier Dutch name, was reintroduced in 1898, when Staten Island became a borough. Before that, the area was called Richmond County. Many businesses still use the Richmond name. Note the National Recovery Administration (NRA) sign. (Courtesy of Joel Cohen.)

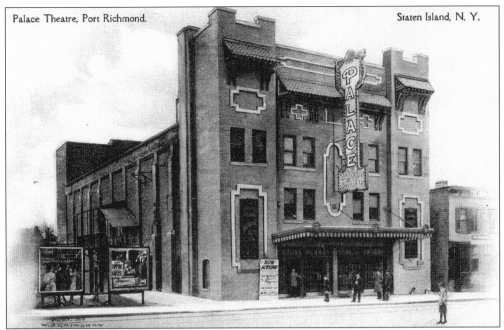

THE PALACE THEATER. The Palace Theater was built in 1915 and had 980 seats. At the theater's peak, each performance saw hundreds waiting in lines that extended from the lobby onto Richmond Avenue. Managed by the Moses brothers, the theater featured big-time circuit acts along with photoplays, which changed twice a week. Matinees were 10¢ and 15¢; evening shows were 15¢ and 25¢. The theater closed in 1951. (Courtesy of the Staten Island Historical Society.)

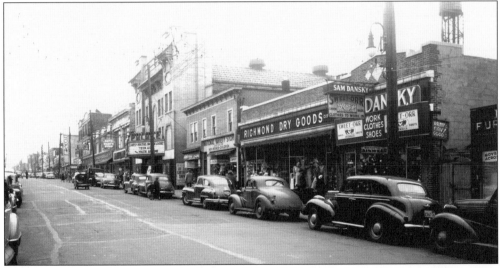

AN ENTERPRISING MERCHANT. At the age of 25 in 1905, Samuel Dansky arrived in New York from Vilna, Russia, and located on Staten Island. He went from house to house selling merchandise. After his parents arrived in 1906, Samuel, along with his father, opened a store on Richmond Terrace opposite a shipyard. Two years later, Samuel relocated to Richmond Avenue. Note the Palace Theater farther up the block. (Courtesy of the Staten Island Historical Society.)

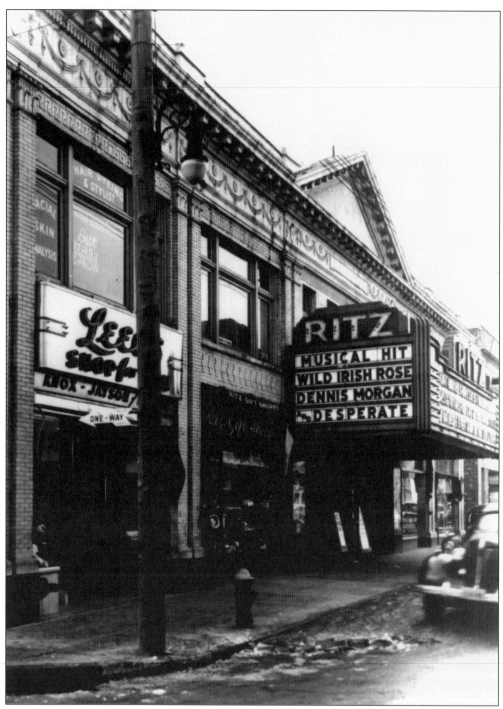

THE LARGEST AND MOST UP-TO-DATE THEATER. The Moses brothers built the Ritz in 1924 in Port Richmond. Its facade was made of glazed Italian ceramic. It had two balconies and a seating capacity of 2,150. On a typical night, a stage show with famous personalities was performed, followed by a movie. The Ritz closed in 1968. (Courtesy of the Staten Island Historical Society.)

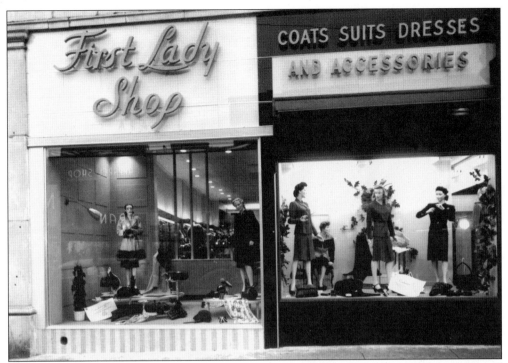

WOMEN'S FASHION. Garber Brothers' First Lady Shop displays the styles of 1946. Richmond Avenue was the center of women's fashions for Staten Island up until the 1960s. (Courtesy of the Staten Island Historical Society.)

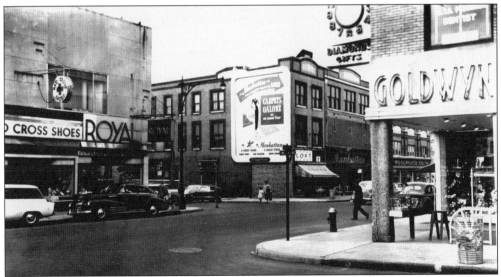

GOLDWYN'S JEWELRY STORE. Goldwyn's Jewelers was located at Richmond Avenue and Vreeland Street. The 54-year-old family business relocated to Forest Avenue in 1975 and closed in 1983. Abraham Jacobson's Manhattan Furniture Company, located across the street in this 1956 photograph, opened in Port Richmond in 1904. Jacobson's son Arthur, born at Staten Island Hospital in 1921, became president of the company after his discharge from the U.S. Air Force. (Courtesy of the Staten Island Historical Society.)

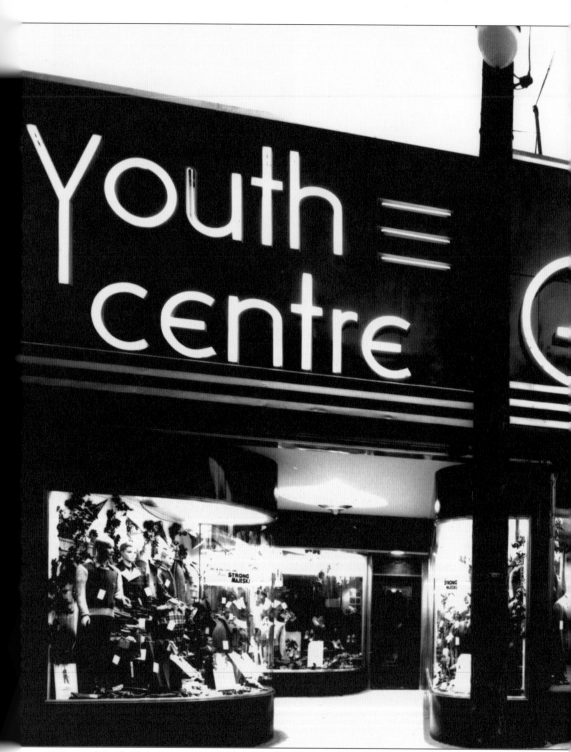

GARBER MEN'S FURNISHINGS. Garber Brothers originally started out with a men's furnishings store on Jersey Street, as seen on page 64. The large Garber store on Richmond Avenue, as shown in this 1946 photograph, carried all the name brands. The windows show samples of all

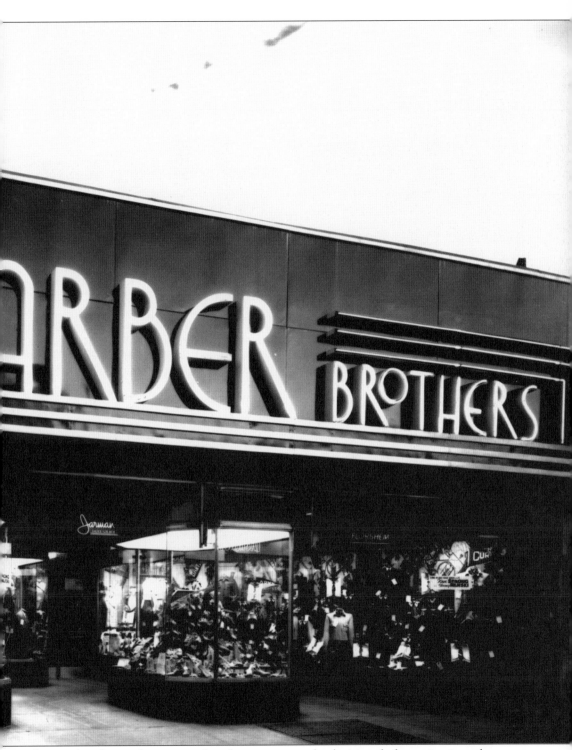

the merchandise in the store so that shoppers can make decisions before going in and can get an idea of what they want. (Courtesy of the Staten Island Historical Society.)

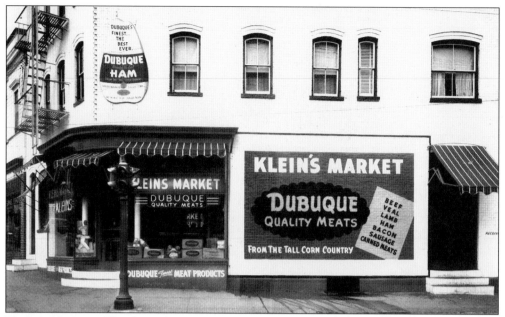

KLEIN'S MARKET. Klein's Market at 251 Broad Street in Stapleton was obviously not a kosher market. Arthur Klein had previously been a wholesaler and supplied ships docked at Port Richmond. When shipping left the area, he opened up a meat market in Stapleton. This photograph was taken in 1941. (Courtesy of Monroe Klein.)

THE UNION FOOD STORE. Jacob Horn moved his business from Jersey Street to Port Richmond in the 1940s. He constructed the building on the corner of Catherine and Decker Streets. The family lived above the store. (Courtesy of Rosalie Horn Brayman.)

THE STATEN ISLAND ADVANCE. The *Staten Island Advance*, the island's only daily newspaper, was bought by Samuel I. Newhouse in 1922 and moved from its West New Brighton location to its new plant in Grasmere in 1960. In 1886, the original owner of the newspaper, John Crawford, turned out 250 copies and sold them for 5¢ each. In 1935, the circulation of the *Advance* rose to 26,800 papers sold for 3¢ a copy. The delivery of the paper required a task force of 300 men and boys. (Courtesy of the *Staten Island Advance*.)

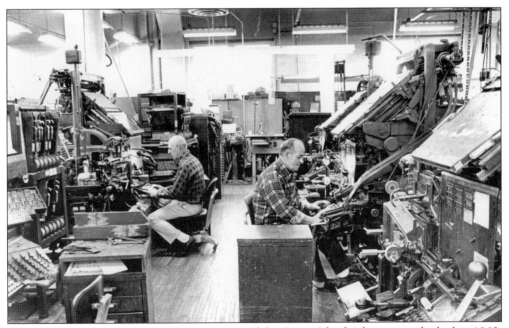

THE PRESSROOM. Seen here is the pressroom of the *Staten Island Advance* as it looked in 1960. Religion was never the basis for hiring at the *Advance*. Family was important. At various times, Samuel Newhouse employed 64 cousins, nephews, in-laws, and other relatives in the many national newspapers and media firms owned by Staten Island Advance Publications. (Courtesy of the *Staten Island Advance*.)

EDITH SUSSKIND'S GIFT SHOP. Husband and connoisseur Alfred Susskind and his wife, Edith, are seen here in 1970 at her new store at 528 Forest Avenue, which featured a collection of porcelain and *objets d'art*. Edith Susskind is a member of the non-sectarian Soroptimists, founded in the 1950s by Staten Island businesswomen. (Courtesy of Edith Susskind.)

THE RITZ THEATER TODAY. Most of the huge building of the old Ritz Theater is behind the storefront and likely used for storage now. Once a magnificent building executed in Renaissance style with marble everywhere, drinking fountains in niches, and every comfort essential to its patrons, the Ritz may not contain much of its former glory. It had one of the largest and best pipe organs, which was furnished by the Skinner Organ Company.

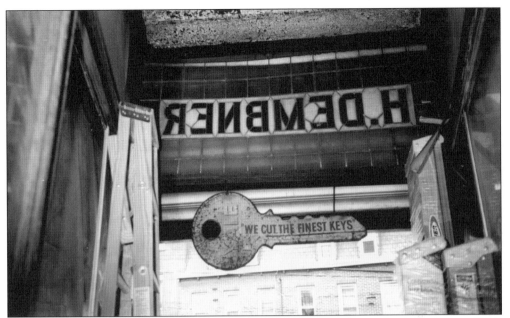

DEMBNER'S HARDWARE. Dembner's has been located at 69 Victory Boulevard since 1921. Some of the fixtures, such as the stained-glass store name over the door and the hanging key, remain, along with the original supply drawers and stock, giving the store a mixture of the past and the present.

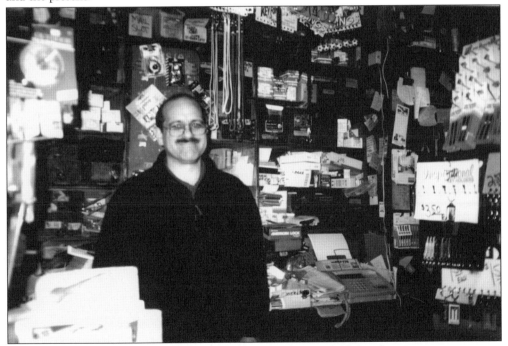

HARRY DEMBNER. Staten Islanders who own older homes find Dembner's a treasure trove. Despite the competition of Home Depot, lots of people like coming to Harry Dembner because he gives the kind of service local stores once provided. There is hardly an item he cannot find or a problem he cannot help solve.

JERSEY STREET TODAY. Many substandard buildings were torn down for public housing projects. Bit by bit, businesses left for other parts of the island or shut their doors. In 1991, New Direction Baptist church, whose reverend is John Dowtin, moved into the old Jersey Street Shul. With the New Brighton Local Development Corporation and other local organizations, it has been actively involved in bringing improvements to Jersey Street. (Courtesy of Colin Reed.)

PORT RICHMOND TODAY. Richmond Avenue may not have the cachet it had a while ago, but new immigrants from Central and South America and new home buyers moving into the area offer hope for the future. The Italian and Jewish presence persists in Tirone's Shoes, Wexler's Furniture, and Richmond Plate Glass. Ralph's Ices and Ice Cream establishment and Denino's Pizzeria still draw crowds.

Five

GROWING UP JEWISH

*Friday, of course, was the time for scrubbing the kitchen floor
and then, spreading the Jewish Daily Forward, the only newspaper brought
to the house, over it until it dried.*

—Charles Weissglass with Joel Cohen,
Smiling Over Spilt Milk, 1972.

At the beginning of the 20th century, everybody worked long hours. Jewish immigrant families usually had 6 to 10 children. Visiting and entertaining were confined to relatives. Kosher food entailed weekly shopping excursions by ferry to the Lower East Side. Tottenville Jews took the ferry to the kosher poultry market in Perth Amboy, New Jersey. The first kosher butcher, Daniel Berezowsky, settled on Staten Island in 1899. Eventually, there were six kosher butchers (one on Richmond Avenue), two live poultry markets, and a couple of kosher delicatessens (one in Port Richmond and one on Jersey Street). In the 1940s and 1950s, Rae Duskin and her sister catered out of their homes. There has never been a Jewish banquet hall on Staten Island. Today, Kaplan's Kosher Catering works out of B'nai Jeshurun.

When only a handful of Jewish families lived on Staten Island, Jewish parents sought marriage partners for their children through mainland relatives and marriage brokers. The new Jewish families that moved to Staten Island before and just after World War I enlarged the marriage pool and were easily absorbed into the community. Men played pinochle and hung out at Jacobi's Kosher Butcher Shop. Women were involved with helping in the family business, the home, and the children.

All Jewish children attended public schools until the opening of the Jewish Foundation School in the 1960s. While some first-generation Jewish children were graduates of private and city colleges, others had to terminate their education in their teens to take jobs to help support their families. The GI Bill of Rights made it possible for many Jewish veterans of the World War II to earn college degrees. Jewish social life revolved around synagogues, the Jewish Community Center, Boehm's Beach, the Catskills, and later the Swim Club. Dating in the 1950s meant going out to ice-cream parlors, Gene's Pizza in Port Richmond, and the Jolley Trolley Diner or taking a spin out to New Jersey. New York City's only drive-in movie theater was located in Greenridge, Staten Island. The Jewish community always availed themselves of the educational, cultural, and entertainment offerings of Manhattan.

Changes in the old Jewish community seemed to happen rapidly "after the bridge." Young people went to out-of-town schools and moved away. The majority of the residents of Golden Gate, the Jewish-run kosher nursing home, are non-Jewish. Because of the absence of Jewish senior housing on Staten Island, many older Jewish residents have moved to retirement villages in Florida and other states. Although many of the old Staten Island Jewish families are gone, the descendants of a number of them are still living on Staten Island, raising families, and participating actively in the everyday life of the island. The after-the-bridge Jewish families now outnumber the before-the-bridge families but, like the latter, are maintaining their Jewish identity and traditions as they become an integral part of Staten Island.

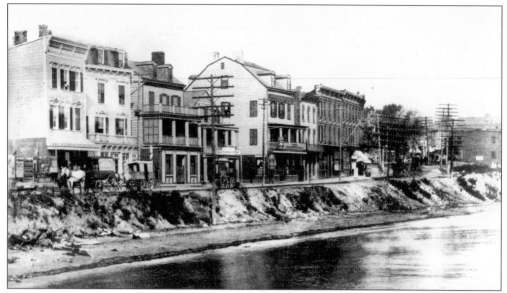

BAY STREET IN TOMPKINSVILLE. Bay Street ran along the northeastern shore. This photograph was taken before the waterline was pushed far enough away to permit the Staten Island Rapid Transit to begin its run from the St. George Ferry to Tottenville. (Courtesy of the Staten Island Historical Society.)

THE FIRST JEWISH CHILD. This Greenwald family portrait was taken at Abram Greenwald's Golden Wedding Celebration at the Jewish Community Center in 1933. Posing, from left to right, are the following: (first row) Mae Greenwald Stein, Abram Greenwald, Emma Greenwald, and Abram's sister Frances Bernstein; (second row) Jacob Stein and his daughter Jane. Abram, born in 1854, was known as "the first Jewish child born on Staten Island." (Courtesy of Jane Stein Aberlin.)

WINTER 1912. Blanche Reitman stands in front of the Reitman home on Richmond Terrace. In 1913, she married Sidney Blum, a Staten Island firefighter who became captain of Hook and Ladder No. 79 at Castleton Avenue and Taylor Street in New Brighton. (Courtesy of Ruth Blum Baker.)

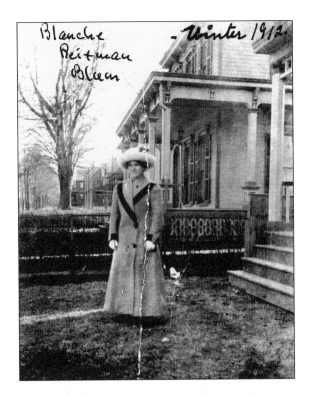

12479—*The Last Call, Volunteer Fire Department, West Brighton, S. I.*

HOOK AND LADDER NO. 79. Horses were still used when the New York City Fire Department began replacing the stations of the volunteer fire companies in 1905. Capt. Sidney Blum and his family lived on Jewett Avenue. (Courtesy of the Staten Island Institute of Arts and Sciences.)

Lillian Simon
Mathematics Course.
Clubs:—Mathematics, Glee, Hunter High School, Menorah.
Offices:—Treasurer of Glee Club '15-'16; *Echo* Reporter Group 71.

Isabel B. Sneddon
Mathematics Course.
Clubs:—Y. W. C. A., Geology.
Office:—*Echo* Reporter '14-'15.
We are about to reveal a great scandal in the life of this woman, so hearken well. It is neither the matinee nor the vaudeville that is her failing—not even the "movies." Hush! speak it with bated breath, she loves above all, the dog show.

Adelheit M. Steeneck
Mathematics Course.
Clubs:—Enterprious, Mathematics, Y. W. C. A., Hunter High School.
Offices:—President Group '12-'15; President Mathematics Club; Student Council Representative '14-'16; Advertising Manager *Wisterion* '15-'16; Reporter *Entre Nous.*
Who would ever think that Etta was the leading horsewoman of Croton Lake. She's an expert on straight roads, but it's a different matter when it comes to turning the steed around.

Gertrude Simpson
Classical Course.
Clubs:—Classical, Hygiene, Child Study.
Timid as Chloe, that fawnlike maid,
Of everything she seems afraid.
That really isn't true, dear reader, for she has never been known to flee from study. She prefers the company of long-suffering Dido and Horace's pale heroines to the modern young women.

Susan Sophian
French Course.
Clubs:—Glee, Arts and Crafts, Fellowship of Goodwill, Cercle Français.
Offices:—*Echo* Reporter Groups 23, 33; Vice-President Group 73; President Group 83; Treasurer Cercle Français '15-'16.
It has always seemed to us a very tragic circumstance that Sister Susie can't try the arts of her soft grey eyes on her French loves across the sea. It must be a just retribution for her scorn of our American youths.

Elizabeth P. Stein
German Course.
Clubs:—Deutscher Verein, Cercle Français, Fellowship of Goodwill, Menorah, Wadleigh.
Just *to* be *different,* she claims that all poets are insane. That must be why she is so attracted by them—especially that greatest and maddest of poets, friend Shake.

HUNTER COLLEGE.

Manhattan's Hunter College attracted a large contingent of young Jewish women from all five boroughs. An all-female free college, it held competitive admission standards. Lillian Simon (top) thought what was written about her in *The Wisterion,* Hunter College's yearbook of 1916, made her sound egotistical, so she cut it out. (Courtesy of Ira Wells.)

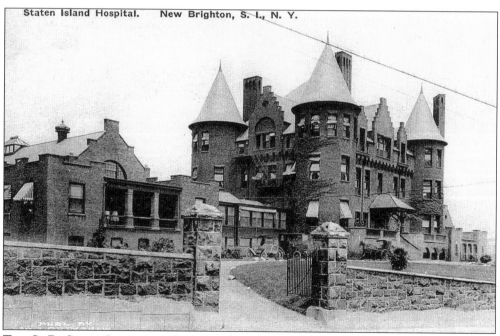

Staten Island Hospital. New Brighton, S. I., N. Y.

THE S. R. SMITH INFIRMARY. In 1890, the Stephen Smith Infirmary moved to Castleton Avenue in New Brighton. Arthur Klein was born in the infirmary in 1908. It was renamed Staten Island Hospital in 1916. Klein's two sons and two daughters were born at Staten Island Hospital, as were Marcia Siegler and her cousin Buzzy Radin. The hospital closed in 1979. (Courtesy of the Staten Island Historical Society.)

READY FOR EMERGENCIES. The S. R. Smith Infirmary's first automobile ambulance is captured in this 1913 photograph. (Courtesy of the Staten Island Historical Society.)

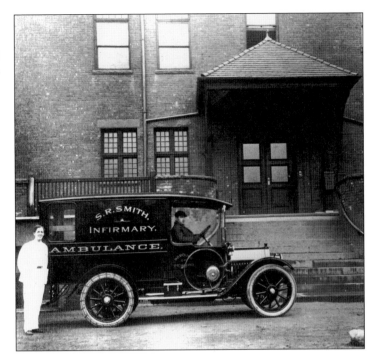

CHAIM WEISS AMBULANCES. The Staten Island branch of the Hatzolah is a volunteer ambulance facility located in Willowbrook, where there is a concentration of Orthodox families. *Hatzolah* means "to save" or "to rescue." It does not serve only the Jewish population. Mark Weiss, a dedicated volunteer, was very active in the rescue operations of September 11, 2001.

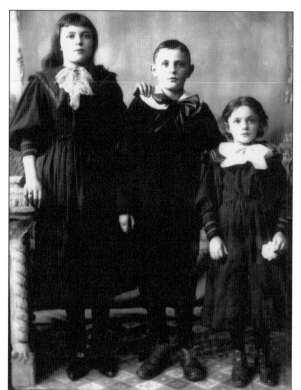

THE MINKOWSKY CHILDREN. Pictured here, from left to right, are Effie, Isadore, and Sarah Minkowsky, age 7, who later married Joseph Rivkin. Their orphaned mother, Anna (not shown), was the niece of Brodsky, the Sugar King of St. Petersburg, Russia. She married salesman Frank Minkowsky and the couple immigrated to the United States. Under the Homestead Act, Frank trained as a tinsmith and got a sound-effects job in a theater, but he died young of appendicitis. Anna, a widow with three children, catered for Manhattan garment manufacturers. (Courtesy of Edith Rivkin Susskind.)

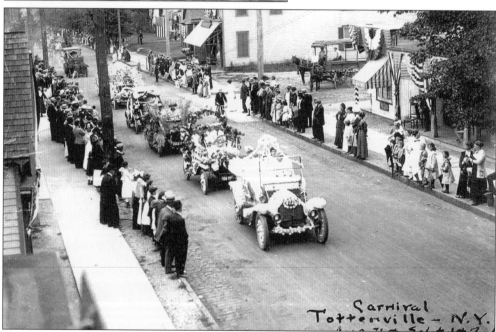

A CARNIVAL. All sorts of carnivals and parades erupted on the North and South Shores at the beginning of the 20th century to the delight of all, especially children. Julie Weissglass of the North Shore interrupted her busy work and family schedule to take her children to a Memorial Day parade at Midland Beach. (Courtesy of the Staten Island Institute of Arts and Sciences.)

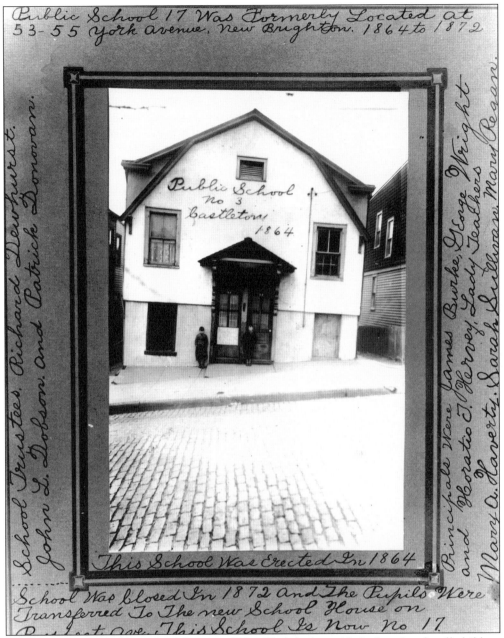

Public School 17 Was Formerly Located at 53-55 York Avenue, New Brighton. 1864 to 1872

School Trustees, Richard Dewhurst, John L. Dobson, And Patrick Donovan.

Principals Were James Burke, George Wright, and Horatio J. Hervey, Lady Teachers, Mary A. Haverty, Sarah Sullivan, Mary Regan.

This School Was Erected In 1864

School Was Closed In 1872 And The Pupils Were Transferred To The new School House on Prospect ave. This School Is Now No 17.

OLD P. S. 3. The Public School System of New York has provided education for all children since 1842. In 1861, 47 teachers ran the public schools. In 1886, the numbers rose to 7,289 students in 28 public schools with 125 teachers. The Stapleton School on Broad Street had 1,284 students. There were an additional 1,000 students in private schools. Public school teaching posts were generally held by Irish Catholic women (see names on frame). This remained true well into the 1940s. (Courtesy of the Staten Island Historical Society.)

KETUBAH. Seen here is the 1927 Hebrew marriage license of Irving and Shirley (Ganchrow) Cohen. Shirley grew up on Van Duzer Street in Tompkinsville. Irving was raised on Benziger Avenue, up the hill from Jersey Street in New Brighton. Shirley's grandparents owned a dry goods store, and her maternal grandfather was a carpenter. Irving's father was a carpenter, too. In 1927, Irving founded the Staten Island Lumber Company with Jesse Raphaelson. (Courtesy of Joel Cohen.)

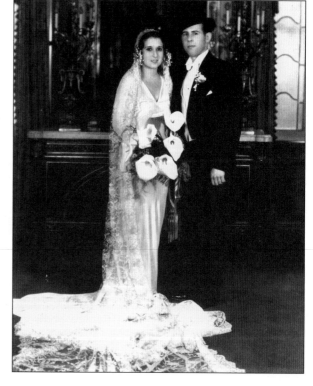

ARTHUR AND INA KLEIN. The eldest of four children, Arthur, at 14, took over the family shipping supplies company and neighborhood meat market when his father died. Ina Blitzer worked for Flagstaff Foods in Perth Amboy. When the order she had taken from Arthur came in all wrong, he called to yell at her. She answered right back. A week later, Arthur called again, this time for a date. (Courtesy of Monroe Klein.)

FRIENDS. Ira Welkowitz poses outside his home at 364 Jersey Street between the daughter of Mr. Levine (the building's owner) and her Gentile playmate in 1926. Jewish and Christian children lived next-door to each other and grew up together on Jersey Street. (Courtesy of Ira Wells.)

TWINS. The left photograph shows Alfred Susskind, born in 1910, at three years old. In the right photograph, the Susskind twins, Arthur and Alfred, are seen. Arthur became a doctor and an anesthesiologist. Alfred became an entrepreneur and antiques connoisseur. (Courtesy of Edith Rivkin Susskind.)

Old P. S. 17. This photograph depicts the school in 1934. Located on Prospect and Fairview Avenues in New Brighton, it was built in 1874 with 31 classrooms for kindergarten through eighth grade. The Genauer children attended. Edith Susskind remembers picking up friends from the Cohen and Lurie families on the way to P. S. 17. The building was destroyed by fire in 1977, and the land was used to create a park. (Courtesy of the Staten Island Historical Society.)

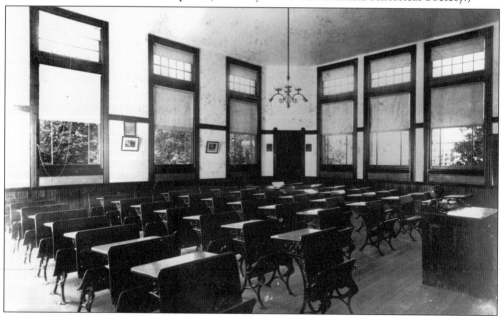

A Classroom in Old P. S. 16. The seats folded up to permit easy cleaning after school. Inkwells were in the upper right-hand side of the desk and were filled on a regular basis by monitors. The large, sliding-door closet with hooks for students' coats, a shelf for storage, and a separate closet for the teacher's clothing is not shown here. (Courtesy of the Staten Island Historical Society.)

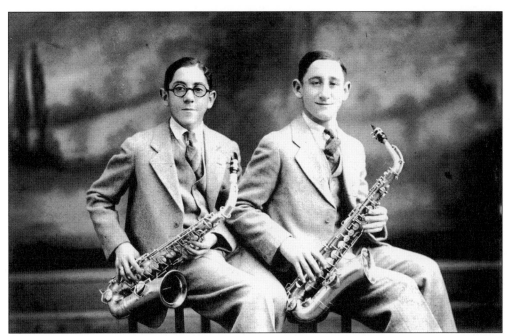

TWIN SAXOPHONE PLAYERS. Arthur and Alfred Susskind, at 14 years of age, comprised a local saxophone band. (Courtesy of Edith Rivkin Susskind.)

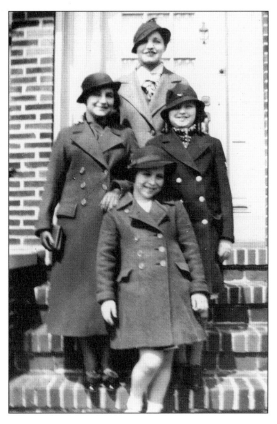

DRESSED FOR A TRIP TO THE CITY.
Cousin "Bunny" (Helene Baumritter, shown in front), whose father was the founder of the Ethan Allen Furniture Company, poses with the Rivkin sisters—Roslyn (top), Edith (left), and Mina (right)—outside their home on Elwood Place, Randall Manor. The Rivkins moved there from Jersey Street in 1929. (Courtesy of Edith Rivkin Susskind.)

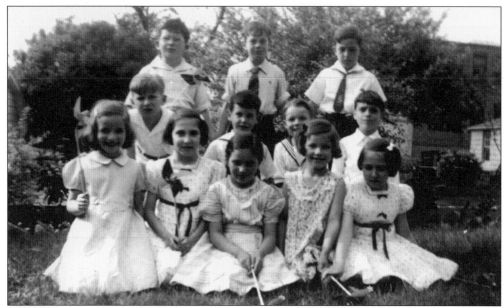

BUZZY'S BIRTHDAY PARTY. Buzzy's eighth birthday party took place in the front yard of the Radin house on Ridgewood Place in 1940. He was named after Franklin Delano Roosevelt's nephew, who was born at the same time. Attendees, from left to right, are as follows: (first row) Sylvia Rafaelson, a Millin twin, Marcia Siegler, Nancy Down, and another Millin twin; (second row) Buddy Walker, Bobby Siegler, Kent Down, and Maxwell Sinowitz; (third row) Seymour Siegler, Buzzy Radin, and Kenny Brennan. (Courtesy of Buzzy Radin.)

PUBLIC SCHOOL No. 20 AND CURTIS HIGH SCHOOL, PORT RICHMOND, S. I., N. Y.

P. S. 20. This school served Port Richmond. In 1925, Curtis High School used the top two floors of P. S. 20 during the construction of an addition to accommodate the increase of its student population.

ALL ALONE. In 1967, Neil Brayman waits for the Jewish Foundation School bus across the street from his house. The school was established to provide a Jewish education for boys and girls consisting of Tefilla (prayer), Parsha (Torah portion), Shabbat, and Jewish holidays combined with math, literacy, vocabulary, social studies, and science skills. (Courtesy of Jacob and Rosalie Brayman.)

THE JEWISH FOUNDATION SCHOOL. The preschool and elementary Foundation School, founded in 1953, characterizes itself as modern Orthodox, with 70 percent of its student body coming from Orthodox homes. It has two sites: an early learning center providing computers, music, aerobics, and trips at Young Israel of Staten Island and a grade school at the Caswell Avenue campus. In 1985, the Jewish Foundation School had 513 students. (Courtesy of Rabbi Boni Sussman.)

CURTIS HIGH SCHOOL. The cornerstone of Staten Island's first secondary school was laid in 1902. Originally named Richmond Borough High, the school was changed to Curtis High in 1903. When Curtis opened in 1904, students traveled by trolley and train to the island's only public high school. (Courtesy of the Staten Island Historical Society.)

WORKING PAPERS. These 1939 photographs of Edith Rivkin were taken for working papers in an automated photo-booth. While a student at New York University, she interviewed for a part-time job with Dryden Press, a publisher of college textbooks. She was hired and was immediately put in charge of promotion for a book convention in Boston. (Courtesy of Edith Rivkin Susskind.)

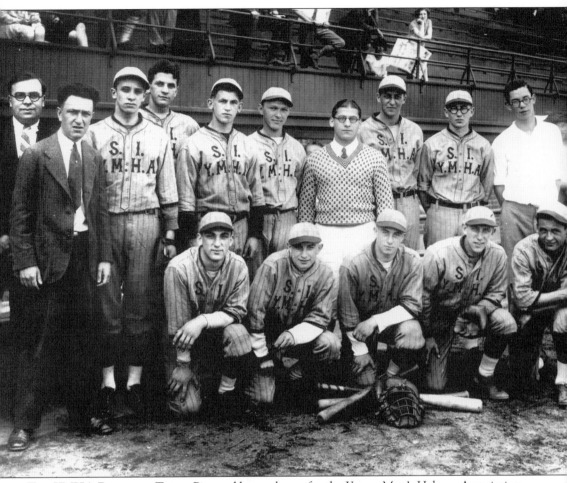

THE **YMHA BASEBALL TEAM.** Pictured here, players for the Young Men's Hebrew Association (YMHA) included Nat Ancelowitz, Louis Bauer, A. Lowenstein, Morty Roseholz, and Sam Hirsch (wearing a sweater). The others are unidentified. The Staten Island Jewish baseball team took the game seriously. Baseball, the most popular American team sport, was closed to Jews and African Americans. Of the 16,700 recorded major league baseball players from 1869 to 2002, only 142 were Jewish. Ten Jewish players changed their names in order to be accepted, and Hank Greenberg and Sandy Koufax are the only two Jewish players in the Baseball Hall of Fame. Jewish baseball teams, formed by local branches of the Young Men's Hebrew Association, played against each other in tournaments. (Courtesy of the Staten Island Jewish Historical Society.)

SILVER LAKE PARK. From left to right, Dorothy Kaplan, Jeanette Borach, and Bess Surpin enjoy an afternoon at Silver Lake Park in 1935. During the Depression, theatrical performances and open-air concerts were given there in the summer. (Courtesy of Harry Toder.)

BOEHM'S PAVILION. Lockers with facilities to change clothing made this New Dorp beach at Sand Lane popular with the Jewish community. In this 1938 photograph, Ruth and Abraham Baker are kneeling and "Bremmy" (Abraham) and Hazel Fleischman are standing. (Courtesy of Ruth Baker.)

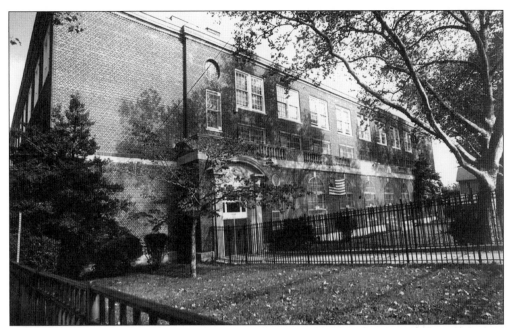

PORT RICHMOND GETS A HIGH SCHOOL. Port Richmond High School opened in 1927 at 85 Saint Joseph Avenue with a capacity for 1,158 students and staff. An addition opened in 1940, adding space for another 876. A wing was built in the 1990s to accommodate the growing school-age population. (Courtesy of the Staten Island Historical Society.)

THE PAN-AMERICAN CLUB. Although many Jewish families lived in Port Richmond, they provided a very small part of the total population of the local schools. Rosalie Horn and her twin sister, Leslie, were members of Port Richmond High School's popular Pan-American Club in 1942. Rosalie is sixth from the left in the third row; Leslie is third from the right in the second row. (Courtesy of Rosalie Horn Brayman.)

PURIM. Jewish festivals became more and more child-centered. Josephine Machol supervises Temple Israel's Purim party in 1961. Purim is a joyous occasion calling for revelry. The *Megilla* (a scroll of Queen Esther's rescue of the Jewish people from Haman, the wicked anti-Jewish vizier) is read, accompanied by noise and tumult to erase the evil Haman. A masquerade and *Purimspiel* (Purim play), in the form of satire and parody, are part of the festival. (Courtesy of Temple Israel.)

GRADUATION. There were two important graduations for Jewish youth: Hebrew school and high school. The 1961 Temple Israel confirmation is shown here outside Veteran's Chapel in Snug Harbor. Pictured, from left to right, are the following: (first row) Leon Taub, Michael Kramer, Ann Selman, Lynne Knie, Pamela Phillips, David Lindner, and ? Cohen; (second row) Tommy Chester, Elizabeth Levine, Ann Atkinson, Deedee Glazer, Judy Dwoskin, and David Mangeim. The third row includes Stephen Lipson, Augusta Stranieri, Rabbi Marcus Kramer, and Edward Wechsler. (Courtesy of Temple Israel.)

A Fraternity Dance. Young men appearing at the 1946 Pi Sigma Phi Summer *Dansant*, from left to right, are Al Avis, Irv Goldsmith, Joel Cohen, and Murray Rubin. Their dates, from left to right, are Blanche Rubin, Judy Waldstein, Phyllis Lipkin, and Doris Budowitz. (Courtesy of Joel Cohen.)

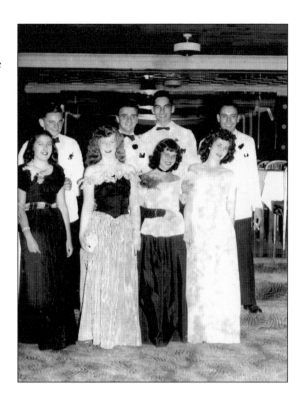

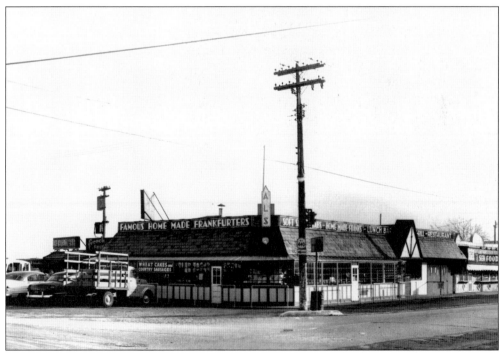

Al Deppe's. All Staten Islanders thought the hot dogs at Al Deppe's in Greenridge tasted great, but the hot dogs were not kosher. The only kosher hangouts were the synagogues and the Jewish Community Center. (Courtesy of the Staten Island Historical Society.)

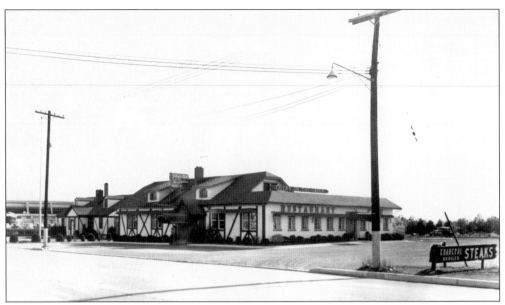

TAVERN ON THE GREEN. Tavern on the Green in Greenridge was more upscale than Al Deppe's. Located near the Greenridge Drive-In Movie, it was the popular restaurant of its day for all Staten Islanders. (Courtesy of the Staten Island Historical Society.)

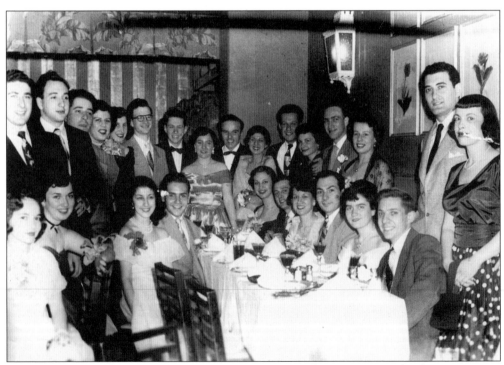

THE GANG'S ALL HERE. The place to meet and party for all young Staten Islanders was Tavern on the Green. Jewish girls did not drink. They usually had non-alcoholic Shirley Temples, Coca Cola, or Pepsi. (Courtesy of Joel Cohen.)

THE COMMUNITY COLLEGE OF STATEN ISLAND. The Staten Island Community College was organized by the New York City Board of Higher Education to provide a free two-year college education for residents. It opened in 1956 at 50 Bay Street in Stapleton and moved to its Sunnyside campus (right) in 1956. (Courtesy of the College of Staten Island Archives.)

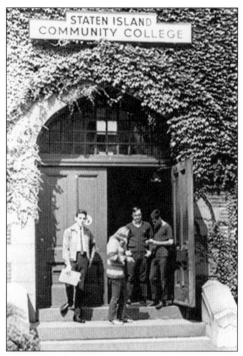

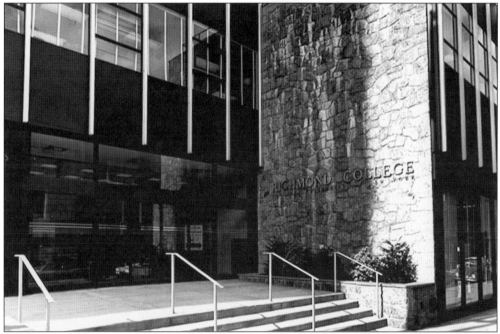

RICHMOND COLLEGE. Richmond College, an experimental college, opened in 1967 at Stuyvesant Place in St. George, offering junior, senior, and some graduate courses for graduates of the Staten Island Community College. Richmond College and Staten Island Community College were combined into the four-year College of Staten Island (CSI) in 1976. CSI used both campuses until it opened on the site of the former Willowbrook State Farm in 1993. (Courtesy of the College of Staten Island Archives.)

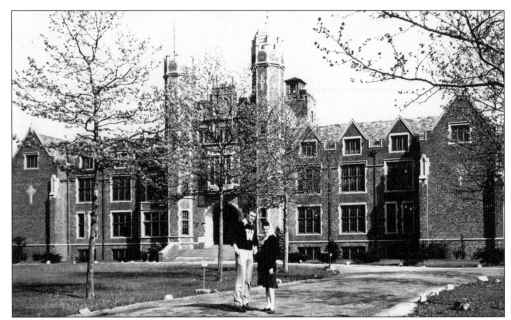

WAGNER COLLEGE. Wagner Memorial Lutheran College moved to Staten Island with 16 students in 1918. Its primary purpose was to prepare young men for the ministry. By 1928, it had broadened its scope to be able to confer Bachelor of Arts and Bachelor of Science degrees. In 1933, it became co-ed. A non-sectarian liberal arts college with Masters degrees in education and business administration, Wagner attracted a number of local Jewish students, especially after World War II. Wagner has recently created a Jewish Studies program. (Courtesy of Wagner College.)

THE SWIM CLUB. Members enjoy the Swim Club in 1974. Tired of being discriminated against by the Richmond County Country Club, Jewish citizens started the Swim Club on Rockland Avenue in the 1960s. Swimming was preferred to the country club's tennis, golf, and horseback riding activities. The club also provided a place to avoid overcrowded and polluted beaches. (Courtesy of Jacob and Rosalie Brayman.)

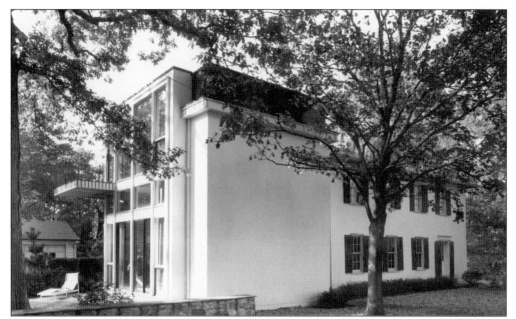

RISING UP IN THE WORLD. As people became affluent, they moved up to Grymes, Todt, and Ward Hills. Michael Diamond's Tudor house on Fort Hill inspired his nephew Harold to become a Staten Island architect. Harold Diamond designed his own house on Grymes Hill, a combination of an original 1832 house and a modern addition. It was featured in *House Beautiful* in May 1970. (Courtesy of Harold Diamond.)

WINTERS IN FLORIDA. David L. Decker visits the Joseph Weissglass family. Decker, from an old English Protestant Staten Island family, was thought to be Jewish by some Staten Islanders because of his Jewish friends and his black hair. Pictured, from left to right, are Joel, Barry, Lillian, David Decker, and Joseph Weissglass at the South Pacific Polynesian Restaurant on U.S. Route 1, south of Hollywood, Florida. (Courtesy of Marjorie Decker Johnson.)

Torahtos Academy Chabad Preschool. There are now a number of Jewish nursery schools on Staten Island. Chani Katzman (center) is shown here with the Menchies, one of two classes at the Willowbrook preschool of the Hassidic synagogue Bais Menachem Chabad Lubavitch. Her assistants, from left to right, are Julie Satt, Merav Nuriel, and special education teacher Alta Heller. Chani's husband, Rabbi Moshe Katzman, is the spiritual leader of the synagogue.

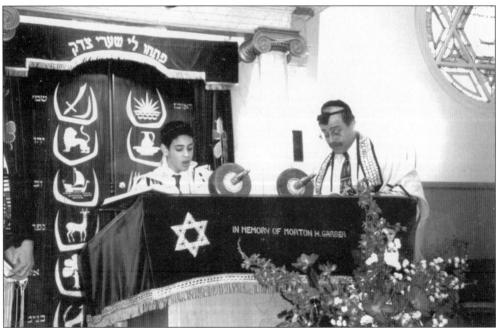

Bar Mitzvah. Jonaton Sussman reads his bar mitzvah *parsha* (portion) from the Torah while his father, Rabbi Gerald Sussman, follows along in his book. Even unaffiliated Jews have their sons bar mitzvahed and celebrate the occasion. Symbols of the Twelve Tribes of Israel decorate the curtains of the Torah Ark. (Courtesy of Rabbi Gerald Sussman.)

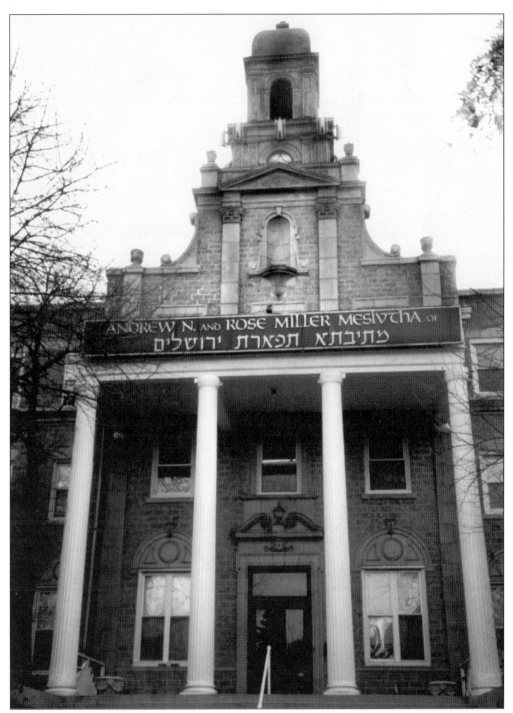

THE YESHIVA OF STATEN ISLAND. A branch of the Mesivta Tifereth Jerusalem of Manhattan, the Staten Island Yeshiva was founded by Rabbi Moshe Feinstein in 1967 in Pleasant Plains near Tottenville. A Jewish high school and post-secondary school, it also has programs for men who are over 18 or are married and a nursery for the children of its teachers and married students.

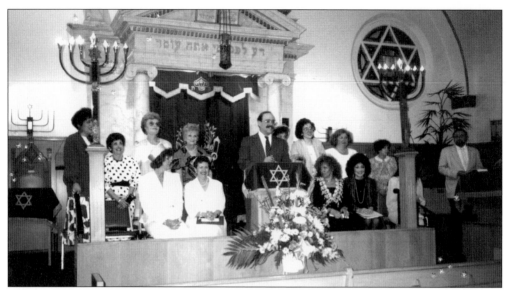

NEVER TOO LATE. Growing up Jewish did not include bat mitzvahs for girls. Many grown women made up for the lack by being bat mitzvahed, often in groups. The ceremonies at Temple Emanu-El included the following people, from left to right: (first row) Rosemary Garber, Amelia Wieder, Rabbi Sussman, Susan Lane, Nancy Shankman, and Roberta Corn-Conti; (second row) Myrna Fein, Phyllis Pollack, Roberta Selisman, Helen Garber, Mary Konner (behind the rabbi), Ula Barrack, Sherry Lustig, and Martha Leopardo. Cantor Jack Schwartz is to the right. (Courtesy of Rabbi Gerald Sussman.)

THE *BRIS*. Irving Rosenbaum holds Joshua as the boy's mouth is dabbed with wine in preparation for the *bris* (circumcision). Joshua's older brother Michael watches. Rabbi Akiva Schiff was the Staten Island Hospital *mohel* in the 1960s. Recently, Romi Cohen—the youngest partisan during the Holocaust, an Orthodox Jew, and a very successful builder—performs circumcisions for free as a mitzvah. (Courtesy of Stephen and Terry Baver.)

Six
COMING TOGETHER

Behold how good and how pleasant it is for brethren to dwell together in unity.

—Welcoming hebrew inscription on the
entrance to the Jewish Community Center

In 1926, the Jewish population on Staten Island was estimated to be 4,000. There were 800 children from 5 to 14 years of age and 1,400 young people between 10 and 30 years of age. The Young Men's Hebrew Association (YMHA) and the Young Women's Hebrew Association (YWHA) with a total membership of 150, the Council of Jewish Women, the Hadassah, the Council of Jewish Juniors and the Junior Hadassah, the Zionist organization, and several social groups were handicapped by the lack of a suitable place to carry on their work. Many citizens felt a compelling need for a community center to impart a better understanding of Jewish culture to Jews of all ages and to help them find joy and pride in their ethnic roots. Ground for the Jewish Community Center (JCC) was broken in May 1928.

From the very beginning, the center had the only indoor swimming pool in the borough. It was used by many of the public and private school pupils and provided an impotant service to the community. During World War II, wounded veterans from Halloran Hospital enjoyed its therapeutic effects. When the armed services needed recreational facilities for its installations on Staten Island, the Jewish Community Center gym was made available to the United Service Organizations. The center gained momentum rapidly and grew quickly, expanding its programs to include a summer day camp, a nursery school, clubs, a music school, special interest groups, and physical education activities. The center's lecture series attracted world-famous personalities like Thomas Mann, Stephen Wise, and Max Lerner. A remodeled and expanded Jewish Community Center was needed by 1962.

In 1985, the community center operated at two sites with a membership of 5,100, representing 20 percent of the Jewish population. The center also sponsored camping for 900 children at its Manor Road Family Park and services to the elderly through senior citizen centers, educational workshops, and recreational programming. The Learning Institute, a state-funded program to help the disabled learn, attracted a large number of non-Jews. The Jewish Board of Family and Children's Services currently provides family services, counseling for adolescents and teenagers, information and referral for senior citizens, and outreach to the unaffiliated. It also operates Geller House, a residential treatment center with space for 25 teenage boys and girls. The majority in treatment are not Jewish. The Jewish Community Center is now in the midst of a capital building campaign to move the center to Mid-Island to better serve the Jewish population.

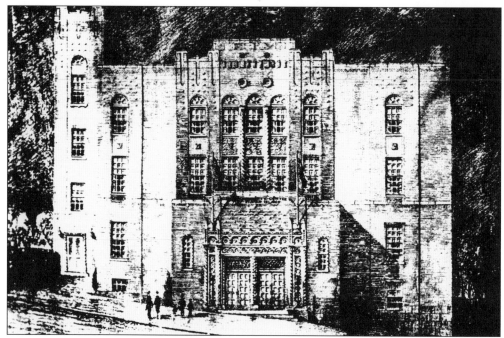

BUILDING A CENTER. This design for the proposed Jewish Community Center was presented by Jewish architects Maurice Usland and Michael Diamond c. 1928. (Courtesy of the *Staten Island Advance*.)

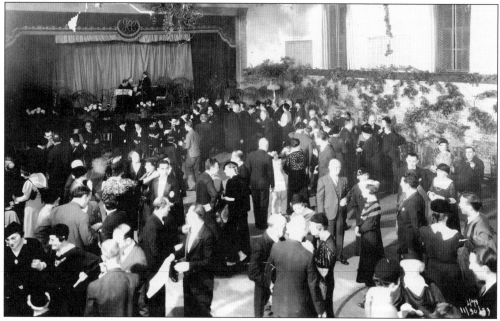

A CELEBRATION HELD IN THE GYM. The Greenwald Golden Anniversary celebration in 1933 was held in the new Jewish Community Center. In 1932, 250 guests, including prominent judges from Brooklyn and leading figures in Richmond's civil and political life, attended a 75th birthday testimonial dinner for Abram Greenwald at the center. The curtained platform in the back made it possible to transform the gym into a theater. (Courtesy of Jane Aberlin.)

YAY, JCC! Ben "Bucky" Rabinowitz, formerly with the Staten Island Young Men's Hebrew Association baseball team, wears the JCC jersey. The team was part of the Jewish Community Center's sports program c. the 1930s. (Courtesy of the Staten Island Jewish Historical Society.)

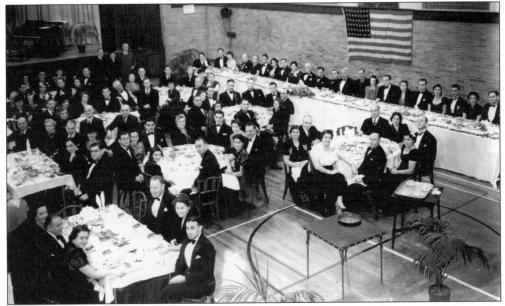

AN IMPORTANT FIRST. The first Federation-United Jewish Appeal dinner was held at the Jewish Community Center's gym in 1939. Every year since then, the United Jewish Appeal has held an annual dinner on Staten Island. More recently, these dinners are held in the large social facility of B'nai Jeshurun on Martling Avenue and catered by Kaplan Caterers. (Courtesy Jane Aberlin.)

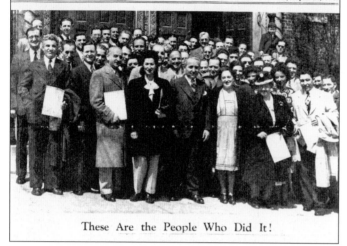

NOW Members of the Jewish Community Center

THE BULLETIN

Published by the ...
Jewish Community
Center of Staten Island

Vol. XIX — No. 33 IYAR 5, 5707 Friday, April 25, 1947

These Are the People Who Did It!

SUCCESS! The center was in danger of losing its property during the Depression. Sara Rivkin, widow of Nathan Rivkin, who had installed all the plumbing and heating, took out a lien on the property of the Jewish Community Center to make it impossible for anyone to buy it. The community worked hard and paid off the Jewish Community Center mortgage in 1947. Sarah Rivkin also forgave the money owed the Rivkin Company. (Courtesy of the Jewish Community Center.)

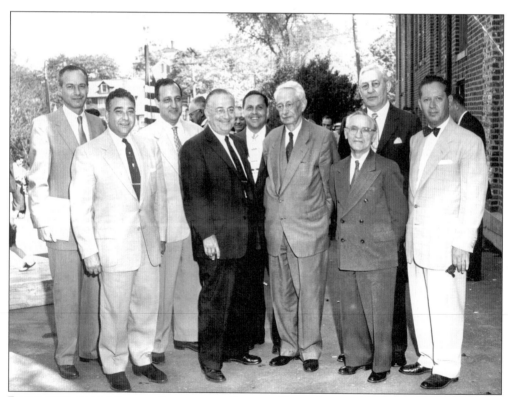

PRESIDENTS OF THE JEWISH COMMUNITY CENTER. Shown here in 1955, from left to right, are Arnold V. Schwartz, Herman "Kelly" Shulman, Isador Aberlin, Ben Cantor, Sol Rubenstein, Herman Friedel, Maxwell Ehrlich, Max Levy, and Jack Friedland. (Courtesy of Jane Aberlin.)

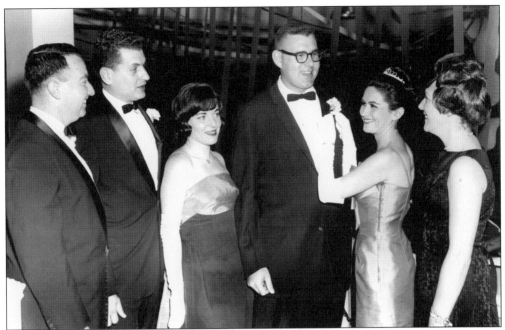

THE JEWISH COMMUNITY CENTER BALL ATTRACTS A CROWD. Marcia Klein, a former Jewish Community Center beauty queen and co-chair of the 36th annual ball in 1964, pins a carnation on Dr. Ronald Leventhal, one of the members of the decorating committee. Pictured here, from left to right, are Vernon Scholar, Isadore Ackerman, co-chair Mrs. Daniel Cantor, Dr. Leventhal, Marcia Klein, and Mrs. Ackerman. Five hundred guests danced to the music of Nino Morreale. (Courtesy of Monroe and Marcia Klein.)

THE JEWISH COMMUNITY CENTER BAZAAR. People of all ages and faiths flocked to this 1955 bazaar. A very popular way of raising money, Jewish bazaars always seem to have attractive clothing in good condition. (Courtesy of the Jewish Community Center.)

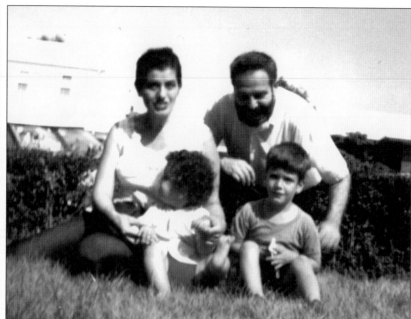

BEHOLD. Above left is the stained-glass window designed by Morton Mintz in 1962 for the Jewish Community Center addition shown below. In the above right photograph, Mintz appears with his Catholic wife, Eleanor, and their two sons, Irving (left) and Daniel (right), on the lawn of their house on Oxford Place. Grandson of a cantor, Mintz worked at the Jewish Community Center for 30 years, first as an art teacher and later as its cultural director. He also designed the eternal light menorah for Temple Israel. (Left, courtesy of Joel Cohen; right, courtesy of Eleanor Mintz.)

THE ISADOR ABERLIN BUILDING. The addition to the Jewish Community Center was named after Isador Aberlin, an attorney and accountant. Aberlin was an active member of the board as well as a past president of the Jewish Community Center. He served as the treasurer and vice president of the Staten Island Bar Association, was a trustee of the Federation of Jewish Philanthropies, and took a leading role in United Jewish Appeal campaigns. (Courtesy of Jane Stein Aberlin.)

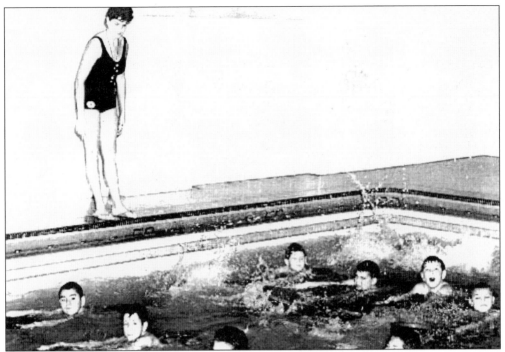

AT THE JEWISH COMMUNITY CENTER POOL. Helen O'Neill, pool director at the Jewish Community Center, gives a flutter-kick lesson in 1963. (Courtesy of the *Staten Island Advance*.)

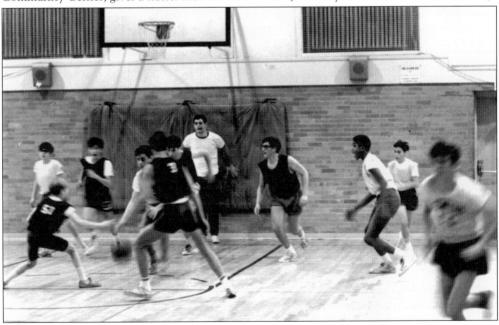

JEWISH COMMUNITY CENTER BASKETBALL. In the 1930s, Mahoney Playground's basketball court on Jersey and Crescent Streets drew players like Joe Sinski, Matty Cronin, Chester Sellitto, Mel and Cedric Ginzberg, Mel Selznick, Bert Levinson, and Red McKinnon. The Jewish Community Center's physical education program, shown here, also draws neighborhood boys. (Courtesy of Rabbis Gerald and Boni Sussman.)

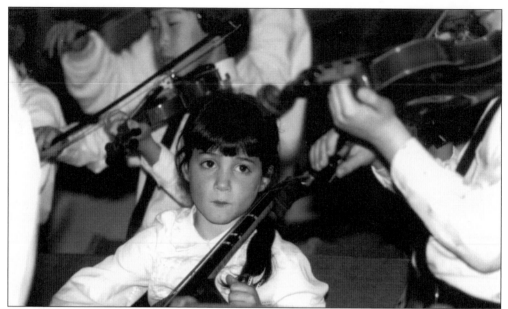

PLAYING AN INSTRUMENT. Aliana Sussman, age eight, learns to play a child's cello at the Jewish Community Center's Music Institute. A non-profit service to the community, the institute aimed to develop in its students—both children and adults—not only performing skills but also an appreciation of music. (Courtesy of Rabbis Gerald and Boni Sussman.)

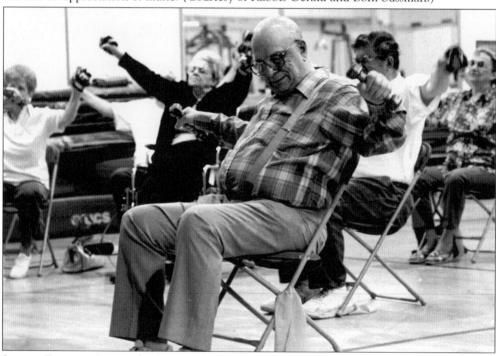

SENIOR FITNESS. Seniors do chair aerobics. The 13 Jewish Community Center senior programs range from Kosher Meals for the Homebound to Senior Olympics. SeniorNet, the Matinee Theater Club, trips, and the Yiddish Club provide cultural and social activities. (Courtesy of the Jewish Community Center.)

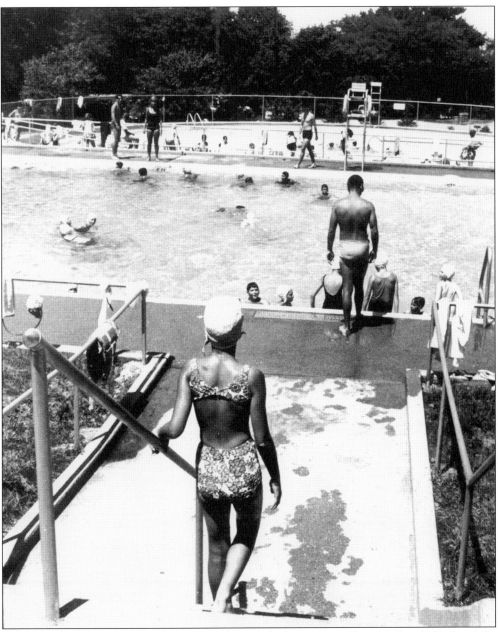

THE FAMILY PARK. At the two pools of the Jewish Community Center's Family Park, adults and youngsters cool off in the summer of 1965. Swimming was forbidden at the Staten Island beaches due to pollution. (Courtesy of the *Staten Island Advance*.)

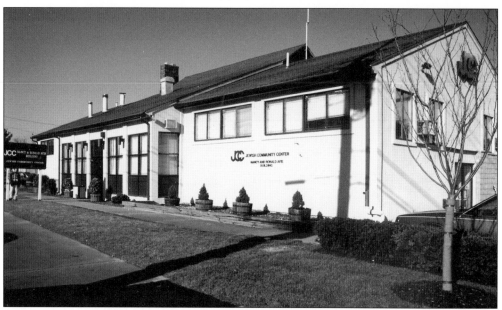

THE SOUTH SHORE JEWISH COMMUNITY CENTER. By the 1980s, a need arose to provide a community center for the increasing number of Jewish families settling in areas other than the North Shore. (Courtesy of the Jewish Community Center.)

A NEW WEIGHT ROOM. The United States, as a nation, is concerned with weight, diet, and exercise, and the Staten Island Jewish community is no exception. Pictured here is the weight room at the South Shore Jewish Community Center. (Courtesy of the *Staten Island Advance*.)

Seven

FIGHTING FOR FREEDOM

Sometimes I would like to think I only imagined the prejudice,
but I knew only too well that it was there.

—Samuel I. Newhouse,
A Memoir for the Children, 1980.

As for anti-Semitism in the early 20th century, "we didn't know that word," writes Charles Weissglass in *Smiling Over Spilt Milk.* "All we knew was that some kids in school said things about us being Jews and we were attacked by the children of the Quarry Gang." By the 1930s, concern had grown over the creeping anti-Semitism fueled by Father Coughlin's *Christian Front* radio program and Henry Ford's money. A number of the members of the social and heritage German Club on Staten Island joined Fritz Kuhn's rabidly anti-Semitic and racist German-American Volksbund, also known as the Bund.

Reports of the rounding up of Jews in Europe into concentration camps were highly disturbing. When the Japanese attacked Pearl Harbor, the Jewish community threw itself into the war effort on all fronts. Every Jewish family lost someone in the Holocaust. In 1948, the Jewish community welcomed the creation of Israel. The Jewish state was called upon, in due time, to provide a safe haven for the persecuted Jews of Iraq, the Soviet Union, and Ethiopia.

The Jewish community of Staten Island has been active in the Democratic Party since the mid-19th century, but the only two Jews ever elected on Staten Island were Republicans. Sidney Jacobi was elected New York City councilman in 1932 and served one term. Robert Straniere has served as New York State assemblyman from the 61st District since 1981.

The Jewish community continues to be concerned about the plight of Jews at home and anywhere in the world. The Consortium of Jewish Organizations (COJO) was initiated in 1967 to be a voice of the entire Jewish community and deal with social issues island-wide. In 1989, more than 100 Soviet Jewish families were placed in a former welfare hotel in Mariners Harbor. The Jewish community collected and delivered clothing, furniture, and food for more than 40 families. The Jewish Community Center Soviet Outreach program was formed in 1990 to provide a range of services from language instruction to assistance in finding jobs and homes. At present, every month, the Consortium of Jewish Organizations services 1,900 Jewish people on Staten Island, including unaffiliated new immigrants, families with children, and the elderly.

HERO PARK. Jewish Staten Islanders fought in World War I and were active in the Liberty bonds campaign. Hero Park was given to Staten Island by Dr. Louis Alexander Dreyfus as a tribute to the 144 Staten Island soldiers who perished in World War I.

A WEDDING PARTY. Around the table, from left to right, are Myrtle Decker Martin, David L. Decker, Cleo D'Alessandro, an unidentified couple, Rudy D'Alessandro, another unidentified couple, and Ruth and Sidney Jacobi at the Riverside Plaza Hotel in New York City. Jacobi and D'Alessandro were partners in a law firm. Decker and Joseph Weissglass were officers of the Richmond County National Bank. (Courtesy of Marjorie Decker Johnson.)

116

An Anti-Semitic Attack. Albert Decker of 1498 Woodrow Road in Rossville, who is custodian of the Jewish Community Center, surveys the damage caused by vandals who destroyed a piano, smashed furniture, and threatened to return. The attack occurred in 1939. (Courtesy of the *Staten Island Advance*.)

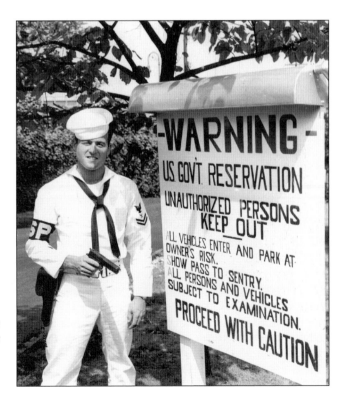

Monroe Klein. Monroe Klein, son of Arthur Klein, joined the Coast Guard and was given a shore patrol assignment. During World War II, the idea that New York City might become a target for the Axis forces was taken seriously. (Courtesy of Monroe Klein.)

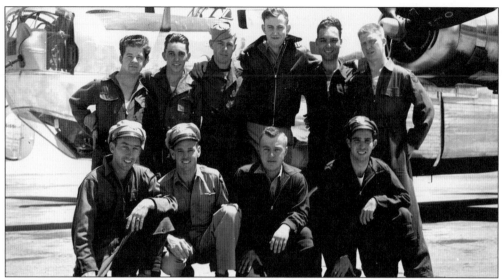

THE CREW OF THE B-67 LIBERATOR. Pictured in 1944, from left to right, are the following: (first row) Lieutenant Cambwin, pilot, Ann Arbor, Michigan; Lieutenant Corder, co-pilot, McCook, Nebraska; Lt. Eugene Pichtencort, bomber, West Point, Iowa; and FO Harold Dorfman, navigator, New York, New York; (second row) Corporal Wells, upper gunner, Sapulpa, Oklahoma; Corporal Barney, ball gunner, Seekonk, Massachusetts; Corporal Wheeler, tail gunner, Dayton, Ohio; Sergeant Benziger, radioman, Brooklyn, New York; Sgt. Ira Welkowitz, waist gunner, Staten Island, New York; and Sergeant Preisel, engineer, Kanakee, Illinois. (Courtesy of Ira (Welkowitz) Wells.)

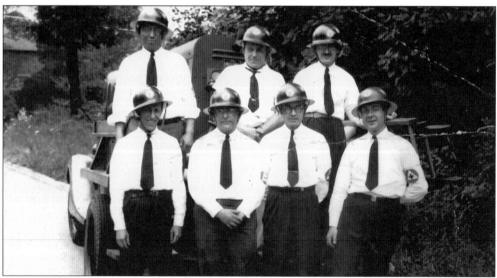

AIR-RAID WARDENS. The Jewish community was very active on the home front during World War II. Blackouts and air-raid warnings were common occurrences. The German bombing raids on London and the threat of rocket attacks were on everyone's mind. Due to its position as the first approach to the Upper New York Bay and Manhattan, Staten Island was particularly vulnerable. A German submarine did penetrate the harbor during World War II but was fortunately discovered and captured. (Courtesy of the Staten Island Jewish Historical Society.)

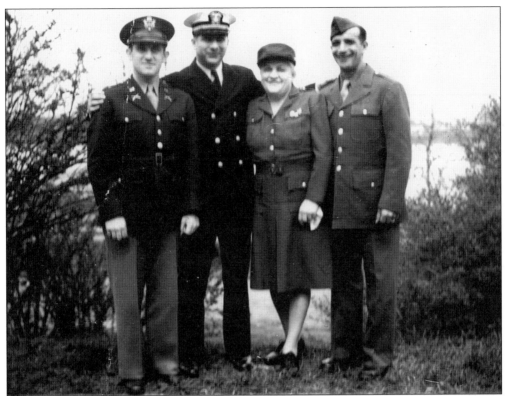

"THE THREE MUSKETEERS" AND MRS. RIVKIN. Seen here in 1945, from left to right, are Isaac Susskind, Judge Advocate Office, U.S. Army; Dr. Mortimer Genauer, U.S. Navy (North African invasion); Sara Rivkin, liaison to the American Red Cross and director of wartime shelter at the Jewish Community Center; and Sgt. Bernard Attinson, U.S. Air Force. As the athletic physical trainer, Attinson called fellow Air Force officer Joe DiMaggio out on a third strike. (Courtesy of Edith Rivkin Susskind.)

A SIMPLE GRAVE. A small American flag draws attention to this lonely grave marker at Hebrew Union Cemetery. As a veteran, Harry Solomon could have been buried in a U.S. Army cemetery, but he preferred to be buried in a Jewish cemetery.

UNITED JEWISH APPEAL. Staten Island Borough President Connor makes a call for the United Jewish Appeal's Person to Person Campaign after signing the proclamation that made the campaign official in 1966. Dr. Jack Feinman stands behind Joel Cohen (right). (Courtesy of Joel Cohen.)

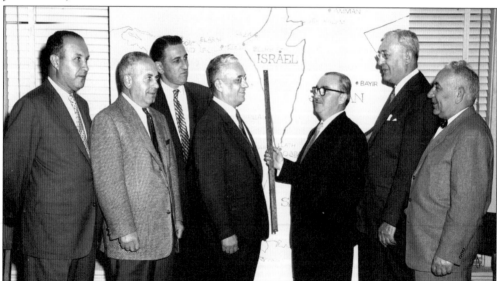

ISRAEL. The United Jewish Appeal cocktail party was held at the Villa in 1956. Former presidents of the Jewish Community Center listen to the guest speaker talk about Israel, a country where the 10-mile distance from the West Bank to Tel Aviv is three miles short of the widest point of Staten Island. (Courtesy of Joel Cohen.)

120

THE STATUE OF LIBERTY'S 100TH. Ralph Lamberti presents the Staten Island Medallion, which honors Staten Island's eminent immigrants, to Egon Salmon in 1985. Salmon—Jewish refugee and winner of three Bronze Stars for his service in the U.S. Army—married Marie Schiff of Richmond Avenue Furniture. His business, Salmon Realty, is now run by his sons Jon and Henry. In 1990, Marie Salmon received an award for organizing parties for Soviet families to celebrate Jewish holidays. (Courtesy of Egon Salmon.)

ARCHBISHOP'S RESIDENCE
452 MADISON AVENUE
NEW YORK, NY 10022

April 13, 1984

Dear Edith,

Bishop Ahern has informed me of your generosity in providing the beautiful gift that was presented to me on the occasion of my visit to Blessed Sacrament Parish. The Bishop has told me that you are not a member of our Faith and so your kindness touches me all the more deeply. May God bless you for your generosity and make you feel His love deeply.

With warm good wishes, I am

Sincerely,

+ John O'Connor
Archbishop of New York

Mrs. Edith Susskind
528 Forest Avenue
Staten Island, New York 10310

A LETTER FROM A CARDINAL. Edith Susskind helped Bishop Ahern on numerous occasions by providing items from her gift shop for fund-raisers and other purposes, so he naturally asked her to select a gift for Cardinal O'Connor upon the cardinal's visit to Staten Island. To show his appreciation, the bishop invited Edith to the gift presentation ceremony at Blessed Sacrament Parish where she was seated up front. This letter from the cardinal followed. (Courtesy of Edith Susskind.)

AN AMERICAN HISTORY LESSON. Susan and Michael Attinson, ages 11 and 7 respectively, visit West Point, New York, in the 1960s. The Jewish tradition of education and respect for history made family trips to important centers of American history commonplace for members of the Jewish community. (Courtesy of Roslyn Rivkin Attinson.)

GOD BLESS AMERICA. On September 11, 2001, Rabbis Gerald and Boni Sussman were stopped by the police as they drove down Richmond Terrace toward the St. George Ferry. Boni was crocheting a red-and-white-striped carriage cover for her new grandchild. The officer, thinking Boni was another Betsy Ross, passed them through. Boni, in response, added stars on a blue field. (Courtesy of Rabbis Gerald and Boni Sussman.)

Eight

MAKING IT

*. . . New Yorkers kiddingly remark about Staten Island that
'no one really lives there' and that there is nothing of
interest on Staten Island.*

—Bruce Kershner,
Secret Places of Staten Island, 1998.

The Jewish community of Staten Island produced no George Gershwins, Lauren Bacalls, Woody Allens, Bernard Baruchs, or Dr. Salks, but it was not without notable members. At the turn of the 20th century, Isaac Almstaedt was called "Staten Island's Most Artistic Photographer." Several of his photographs are reprinted in this book. Ada R. Singer was Staten Island's first woman lawyer. Dr. Louis A. Dreyfus, a chemist and inventor, patented Cold Water Paint, which was leased to the Muralo Company in New Brighton. He also invented artificial rubber and discovered the chicle that makes chewing gum chewable. Abel Kiviat was Staten Island's Olympic track and field star and Jim Thorpe's roommate on the boat to the 1912 Stockholm Olympics. Samuel I. Newhouse bought the *Staten Island Advance* in 1922 and turned Staten Island Advance Publications into the mega-media giant that now owns *Vogue,* the *New Yorker,* and Random House Publications. Emily Genauer won a Pulitzer Prize for her art criticism and writing in 1974. Graenum Berger, director of the Jewish Community Center, was instrumental in securing Israeli recognition of the Falashim of Ethiopia as Jews, resulting in dramatic airlifts that rescued 50,000 Falashim and brought them safely to Israel. Portia Diamond was the founder and guiding force of the Staten Island Children's Museum. The museum serves an audience of 170,000 annually, composed of school groups and families from the tri-state area, and has deservedly won national acclaim. The Jewish community is proud of all these accomplishments.

The Jewish community is also proud of those members who have contributed to the well-being of its own community and to the general welfare of Staten Island. Members of the Jewish community have participated in the labor, civil rights, and feminist movements, helped save Snug Harbor from developers, and worked for the Preservation League and Mud Lane Society to preserve the neighborhoods and architectural heritage of Staten Island. They have served in many capacities on the boards of St. Vincent's Hospital, the Richmond County Country Club, the Staten Island Institute of Arts and Sciences, the Staten Island Historical Society, the chamber of commerce, the Staten Island Symphony, and others too numerous to mention, and have been honored by these institutions. The Marcus G. Kramer Award of Project Hospitality was named after the much-loved rabbi of Temple Israel. Of the 268 Staten Island Advance Women of Achievement Awards presented since its inception in 1962, 27 went to Jewish women. Although the Jewish community is a minority on Staten Island, its impact has been major.

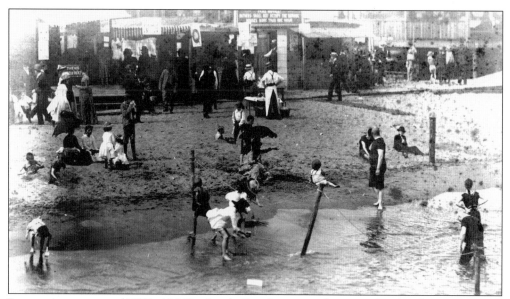

ISAAC ALMSTAEDT (1851–1921). South Beach, a popular spot for family outings, was photographed by Isaac Almstaedt. Beginning photography in 1873, Almstaedt attracted clients like Charles Scribner, Bill Nye, Buffalo Bill, Cornelius Vanderbilt, and Perry Belmont. He photographed countless local buildings and landscapes and made innumerable stereoscopic pictures. His work appeared in *Picturesque Staten Island* and *Illustrated Sketch Book of Staten Island*. He was the best-known Staten Island photographer of his day. (Courtesy of the Staten Island Historical Society.)

A U.S. OLYMPIAN. Abel Kiviat (1892–1991) is the contestant at the left end of the starting point of the 1912 Stockholm Olympics. An alumnus of Curtis High School, he lost the gold medal by one second in the first-ever photo finish. The Abel R. Kiviat Memorial Track and Field Award is given annually at Curtis High School. An incredible athlete, Kiviat was inducted into the U.S. Track and Field Hall of Fame in 1985. (Courtesy of the Staten Island Institute of Arts and Sciences.)

SAMUEL I. NEWHOUSE, 1951. Newhouse (1896–1979) was the first of eight children of immigrant parents. At 26 years of age, Newhouse bought the *Staten Island Advance*. It became the centerpiece of his company, Advance Publications. By the time of his death, Newhouse had added seven magazines, six television stations, five radio stations, and several cable-television franchises to his 37 newspapers across the country, and employed 15,000 people in 11 states. (Courtesy of the *Staten Island Advance*.)

FDR JR. COMES TO STATEN ISLAND, 1955. Rabbi Benjamin Wykansky presents an Israel Bond Drive plaque while honored guest Elliot Roosevelt looks on. "I have to ask a favor," Elliot told his hosts. "Don't tell my mother [who lives in Manhattan] I'm in New York because I didn't call her." (Courtesy of Joel Cohen.)

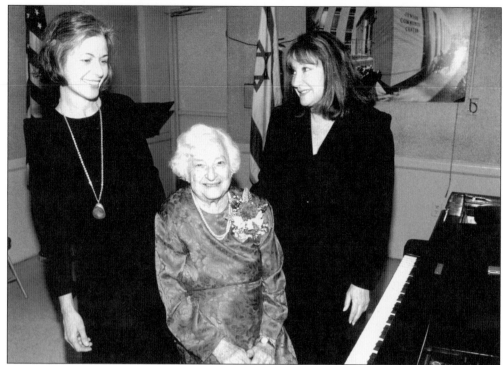

DOROTHY DELSON KUHN HONORED. Pictured at the naming of the Dorothy Delson Kuhn Music Institute, are, from left to right, Bertha Mandel, Dolly Kuhn (at the piano), and Sheila Lipton. Many buildings and sites on Staten Island were named for prominent members of the Jewish community, from the Elias Bernstein Intermediate Public School to the Weissglass Speedway. (Courtesy of the Jewish Community Center.)

COURAGE AND A DREAM. In 1973, Portia Diamond felt the need to create a center on Staten Island similar to the Brooklyn Children's Museum. Portia mobilized parents and approached civic leaders, foundations, and public officials. In 1976, the Staten Island Children's Museum opened in a storefront on Beach Street in Stapleton, shown here. In recognition of Portia's contribution, the trustees established the Weinsoff Fund in honor of her parents. (Courtesy of the Staten Island Children's Museum.)

THE CHILDREN'S MUSEUM MOVES TO SNUG HARBOR. The Staten Island Children's Museum opened its doors to its new home in Snug Harbor in 1986. The museum was now able to present four exhibitions simultaneously and to schedule workshops and performances inside as well as outside in a park setting. One-third of the classes served are Title 1 and one-tenth are special education. The museum participates in more than 20 outreaches annually. (Courtesy of the Staten Island Children's Museum.)

BIGGER AND BETTER. The ribbon to the children's museum's new barn addition is about to be cut. In front of the ribbon, from left to right, are Jacqueline Bouguio, Abraham Jacobs, Vincent Gangemi, Zachary and Zoe Tirado, and Joseph and Emily Marks. In back of the ribbon, from left to right, are David Prendergast, Robert Gentile, Eileen and Catherine Connors, David Ceci, Katherine Connors, director Dina Rosenthal, Cesar Claro, Stephen Fiala, Mark Irving, and Portia Diamond. Behind Fiala, from left to right, are Vincent Bellafiore, Laird Klein, and Ken Tirado. (Courtesy of the Staten Island Children's Museum.)

POSTSCRIPT

THE FIRST ANNIVERSARY OF SEPTEMBER 11TH. The interfaith gathering was held at the Richmond County Bank Ballpark stadium in St. George, Staten Island, overlooking the New York Bay across from the site of the World Trade Center terrorist attack. Included on the dais are family members of victims. (Courtesy of the *Staten Island Advance*.)